About Bee Morrison

I have been painting since an early age and have always endeavoured to develop an individual style of painting that is colourful and atmospheric. At times it is also very impressionistic.

I made art my career after attending art school as a mature student during the mid-seventies and gaining an Honours degree in three-dimensional design. I started out as a freelance art teacher, a job that still takes me regularly all over the UK, as well as further afield on cruise-ships travelling to destinations around the world. For a number of years I was also an artist in residence at many schools in and around Manchester, England.

I have had two television appearances; the first on a gardening programme for which I painted three giant murals of lavender fields in Provence, France, as part of a garden design. The second was as a contestant on a popular watercolour painting programme for which I was lucky enough to travel to Provence in order to paint the lavender fields first-hand.

Many of my images have been adapted as cross-stitch kits by Derwentwater Designs of Penrith and these are distributed worldwide. My paintings also appear as designs on cards.

Bee

CONTENTS

 WORKSHOP ONE

 WORKSHOP TWO

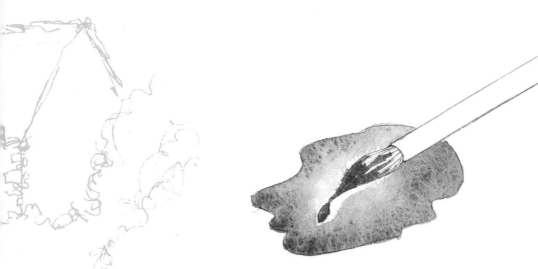

WORKSHOP THREE

WORKSHOP FOUR

INTRODUCTION

Watercolours are the perfect medium for capturing the subtle beauty of nature and landscapes. Colours can be strengthened or watered down to create a wide range of effects that suit anything from close-up images of flowers to dramatic sweeping scenes.

Divided into four workshops this book leads you through various watercolour techniques that gradually increase in difficulty as your technique improves. Each workshop is split into four subject areas – landscapes, flowers, cottages and trees – to develop your eye for different types of composition. All the projects are presented in a fully illustrated step-by-step format with clear instructions on how to achieve excellent results. Possible variations for each project are also offered as inspiration for further progression. By working through each level of workshop, the beginner to watercolour painting will find all the guidance and inspiration they need to become proficient enough to go on and create beautiful compositions on location.

Equipment

Before you begin it is a good idea to check that all your equipment is arranged so that everything is easily accessible to you when working. Make sure brushes, paints and water pots are near to your working hand. The lay-out below is for a right-handed person and shows materials that are used throughout this book. All the projects in this book have been done on 140lb (300gsm) watercolour paper, which is a medium surface paper. Watercolour paper can be bought as loose sheets, blocks and pads.

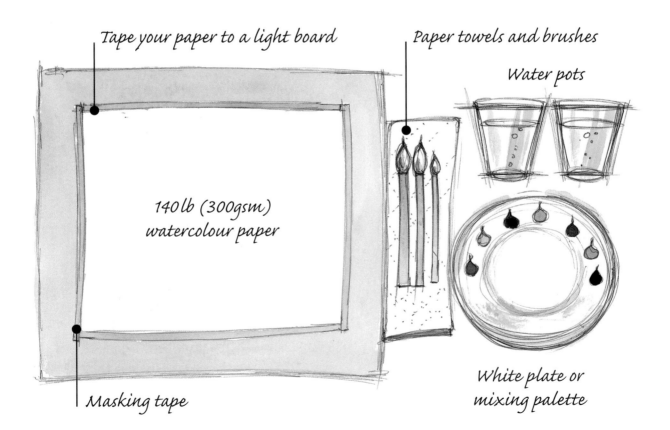

Tape your paper to a light board

Paper towels and brushes

Water pots

140lb (300gsm) watercolour paper

Masking tape

White plate or mixing palette

As you become more involved in watercolour painting you will no doubt want to add to your range of tools and paints but you will find that you can achieve some wonderful results using the minimum of equipment and when building up your technique it helps to start with very simple colour palettes. The illustration below shows all the equipment you will need to work through the projects in this book. For some projects you will need to use more than one of some of the brushes.

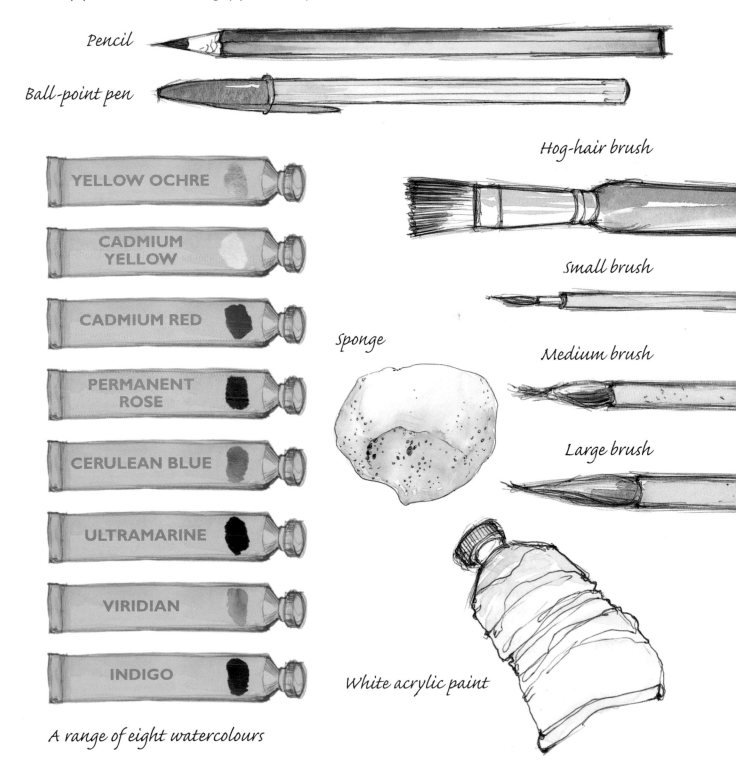

Pencil

Ball-point pen

Hog-hair brush

YELLOW OCHRE

CADMIUM YELLOW

CADMIUM RED

Small brush

PERMANENT ROSE

Sponge

Medium brush

CERULEAN BLUE

ULTRAMARINE

Large brush

VIRIDIAN

INDIGO

White acrylic paint

A range of eight watercolours

Techniques

The projects in this book are divided into four increasingly advanced 'workshops'. Each of these workshops takes four popular watercolour subject matters – landscapes, flowers, cottages and trees – and through these introduces a range of exciting painting techniques.

THUMBNAILS

These are small quick sketches for which you can use either a pencil or a ball-point pen. They are useful for giving you a feel of which elements of a scene to include in your finished painting.
Used in Workshop 1 – 'Country Cottage' and in Workshop 2 – 'Indigo Sky'

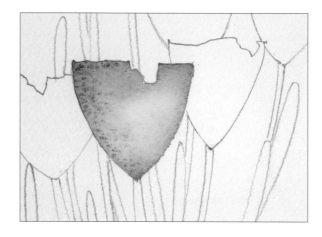

JIGSAW PAINTING

Non-adjacent areas of the painting are worked on a section at a time in order to allow drying time while you continue to work.
Used in Workshop 1 – 'Tulips'

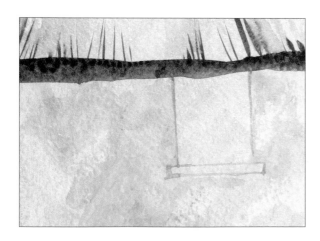

DRY BRUSHING 1

As the paintbrush runs out of colour it becomes suitable for a dry brush technique. For this the brush is laid flat and the paint is distributed less strongly for a speckled effect.
Used in Workshop 1 – 'Country Cottage'

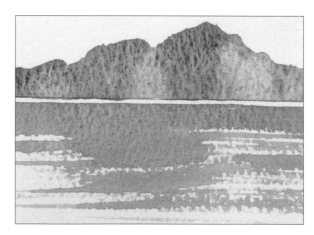

DRY BRUSHING 2

A brush that is well loaded with paint is used flat on the paper so that the hairs create a striped or speckled texture, which is ideal for suggesting sparkling water.
Used in Workshop 1 – 'Blue View'

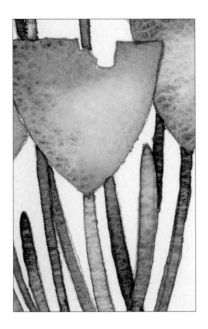

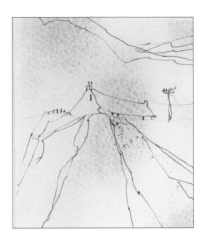

WATERCOLOUR OUTLINING

Water is dropped gently onto a newly painted shape to create an outline. This is also referred to as 'watermarking'.

Used in Workshop 1 – 'Tulips'

WET-IN-WET

The paper is wetted and a brush is used to add either more water or colour to this area (see 'Paint a sky in four easy steps', page 12). The technique can be used to add colour to a specific area (positioned tint, above left) or to create an abstract background (random tint, above right).

Positioned tint used in Workshop 1 – 'Blue View'
Random tint used in Workshop 2 – 'Cottage in the Mountains'

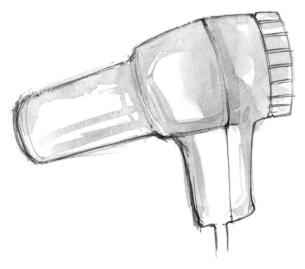

WET-ON-DRY

A pale watery colour is used to lightly paint a shape that suggests a track.

Used in Workshop 2 – 'Indigo Sky'

DRYING TIME

Newly painted areas are allowed to dry slightly before a hairdryer is used to speed up the drying time. This technique is used throughout.

Technique: Mixing paint colours

A wide range of colours can be mixed using the paints shown on page 9. Experiment with different combinations such as those shown here. Mix the paints on your plate or mixing palette and dilute them with water to achieve different strengths.

Indigo +
Permanent Rose

Permanent Rose + Ultramarine

Cadmium Yellow + Indigo

Technique: Paint a sky in four easy steps

Medium brushes

Small brush

Ultramarine

Paper Wetness

Wet paper goes through various stages; it will look quite shiny when it is very wet, but then as the paper starts to dry it will look matt.

Dabbing

A loaded brush will release its colour more readily by dabbing it on the paper wetness.

1 PREPARING THE PAINT
Use the first medium brush to make a large watery ultramarine puddle on the plate or mixing palette. Leave the brush in the puddle ready to use later. Experiment with making the colour of the puddle stronger and weaker, this will change the look of the finished sky.

2 WETTING THE PAPER
Use the second medium brush to wet the paper all over. Tip the paper so that the water gathers in one corner then use a paper towel to absorb the excess.

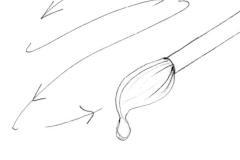

3 ADDING THE SKY COLOUR
While the paper is still wet use the brush loaded with ultramarine to dab the colour at the top then tilt the paper carefully so that the colour runs across it.

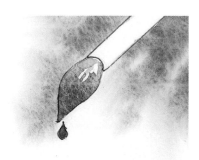

4 CONTROLLING THE COLOUR
Flatten the paper to stop the colour from running too far into the picture. Collect the excess in a corner with a paper towel.

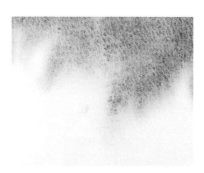

Blue View

This project shows how to identify the different features
of sky, land and sea using three simple techniques

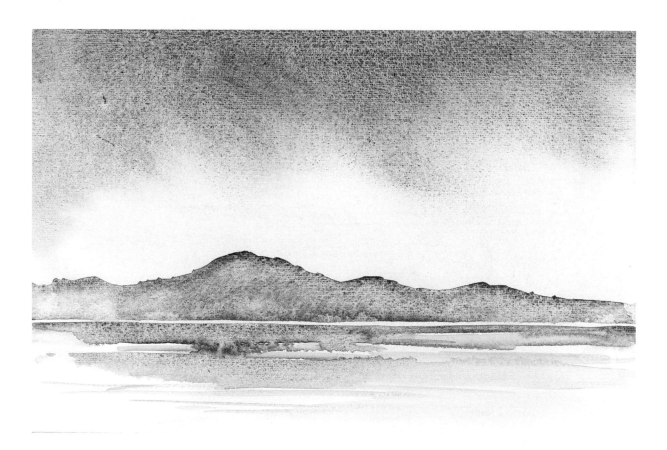

You will need:

2 Medium brushes

1 Small brush

Ultramarine

This painting is equally effective in different colours

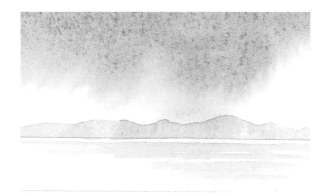

The same composition painted in cerulean blue

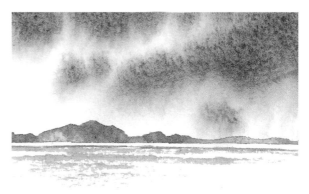

Painted in a mix of ultramarine and permanent rose

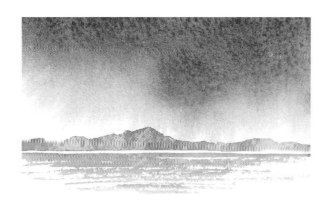

Painted in permanent rose

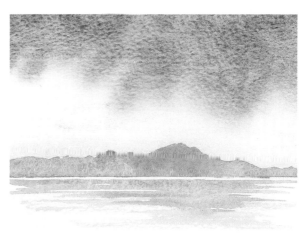

This variation is painted with yellow ochre on a damp sky after the blue painting has been completed

SKY

Using a medium brush prepare a large watery wash of ultramarine to use for the whole picture. Keep this puddle and its brush ready to paint the sky. Apply clean water all over the picture with a second brush. Tip the paper towards a corner to collect the excess water with a paper towel. With the first brush dab some of the ultramarine onto the top of the wet paper to create the sky, tilting the paper slightly to allow the colour to move on its own through the wetness. If the colour runs too fast, lay the board flat to stop this movement. If the colour does not run at all, wet the paper a little to allow the colour to flow. Collect any excess water in a corner with a paper towel.

Once the shine has gone from the paint, dry the paper using a hairdryer. Once the picture is dry mark the base of the mountain area. Use a pencil to draw a light line one third of the way from the bottom edge.

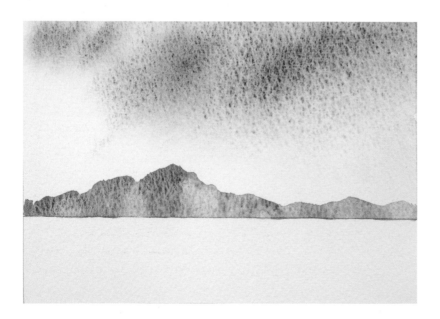

2 MOUNTAIN

Using the small brush and the same coloured puddle, practise the mountain shapes and the different ways of painting them. Choose one of the methods on page 17 to create the illusion of distant mountains.

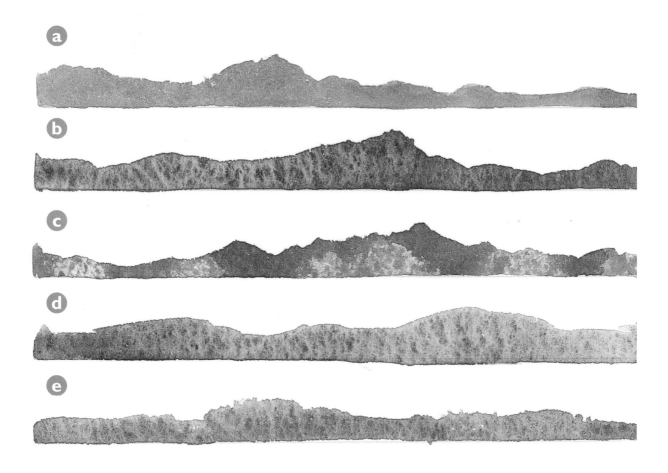

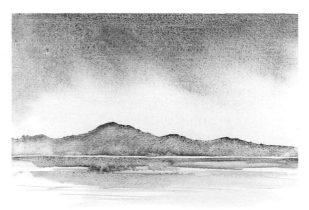

a) Flat colour mountain: with a totally loaded brush, paint the mountain shape moving the brush along the paper from one side to the other.

b) Flat colour watermarking: before the flat colour mountain shape dries, add a small amount of water to make the watermark appear.

c) Flat colour dabbed: before the flat colour mountain shape dries, dab with a paper towel to create two tones.

d) Wet-in-wet: wet a shape in the form of a mountain then dab the colour in and tilt the paper to make the colour flow.

e) Half and half: pre-wet part of the paper above the pencil line and paint the mountain across this area. This will give a different effect to the finished mountain shape.

3 FINISHING TOUCHES

Leave a narrow gap between the mountains and the water. Use a small brush and load it with the watery ultramarine wash. Lay the brush flat to the paper so that the paint is distributed less strongly creating a speckled effect. This technique is called 'dry brush'.

Tulips

By painting this attractive tulip composition you will learn the basic principles of two new techniques: 'jigsaw painting' and 'watercolour outlining'

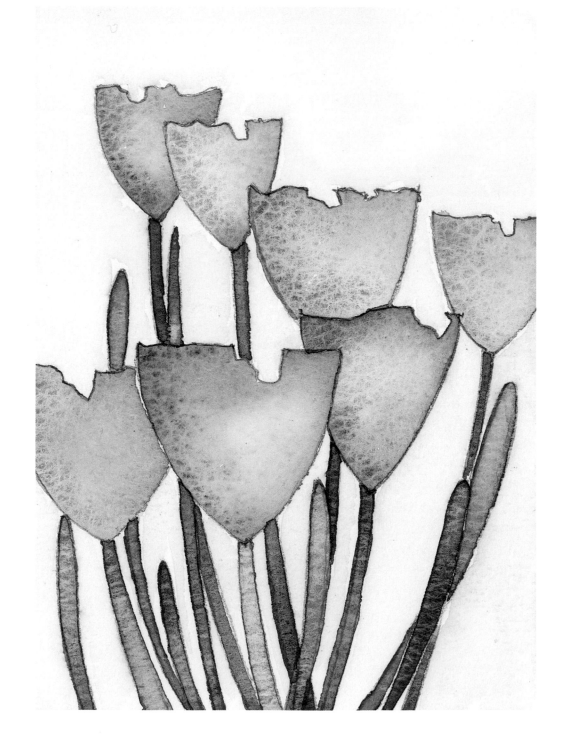

You will need:

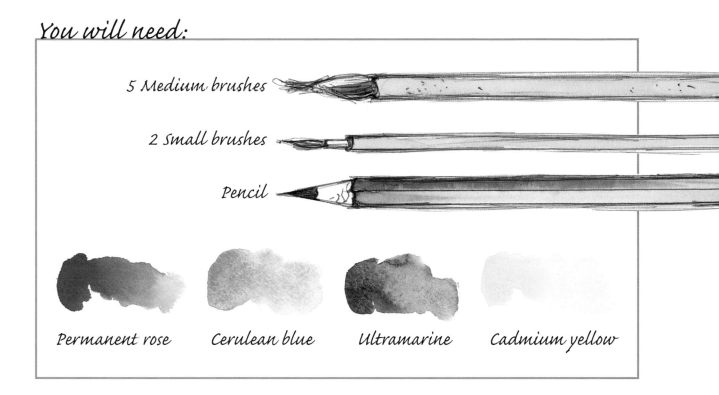

5 Medium brushes

2 Small brushes

Pencil

Permanent rose Cerulean blue Ultramarine Cadmium yellow

SKETCHING OUT

In pencil, draw a rectangle that is 4 x 6in (12 x 17cm). Draw the largest tulip outline using a soft pencil. Make its stalk slightly curved.

Arrange other tulip shapes, stalks and some leaves around the main flower. Before you start to paint, partly erase some of the pencil lines to leave lighter marks. This creates a softness to the image.

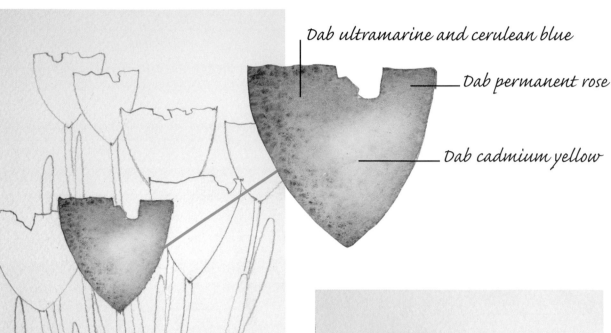

Dab ultramarine and cerulean blue

Dab permanent rose

Dab cadmium yellow

2 PAINTING THE FIRST FLOWER

Prepare all four colours in puddles with a separate brush for each colour. Using the fifth brush, carefully wet the shape of the largest tulip. Tip the paper to collect the excess water in one corner then dab with a small piece of paper towel. Lay the paper flat again and dab in cadmium yellow just off-centre. Dab in permanent rose to the right side and two blues, ultramarine and cerulean blue, to the left side. The colours will partly overlap as they flow over the wet surface. Dab the same sequence of colours into each flower.

Tip the paper to gather the excess and dab it off. This method of 'jigsaw painting' means painting in areas that are not side by side so that no wet colours bleed into one another.

3 ADDING MORE FLOWERS

Using the jigsaw method, continue to paint more flowers following the steps used in Stage 2.

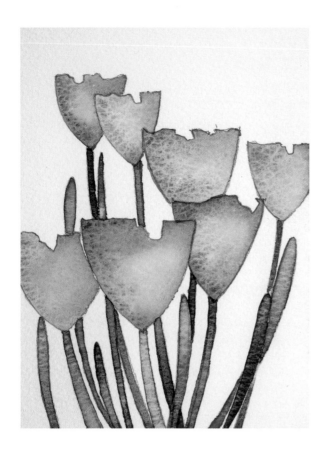

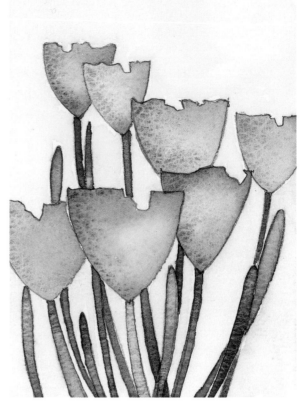

4 STALKS AND LEAVES

One at a time paint the stalks and leaves using a 'watercolour outlining' method (as described on page 11). With a small brush and a strong ultramarine puddle, paint the whole of the shape. Before it dries, use the second small brush to add clean water to the shape. Tip the paper downwards to collect the excess water where it runs off the edge of the leaf. The shape will now have a fine outline. While this area is still wet you can add small amounts of your other colours, collecting the run-off at the bottom of the tipped paper. Dry the paper.

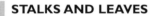

5 BACKGROUND

The colours of the flowers in this painting are very bright, so you will find that only a delicate background is needed. With a clean brush, wet each small section of background and then drop in some cadmium yellow and some permanent rose, wet-in-wet. Dry the paper.

Try experimenting with the strength or weakness of the flowers and the contrast of the background.

Country Cottage

This painting incorporates the use of acrylic paint to add
texture and substance to the wall of the picturesque cottage

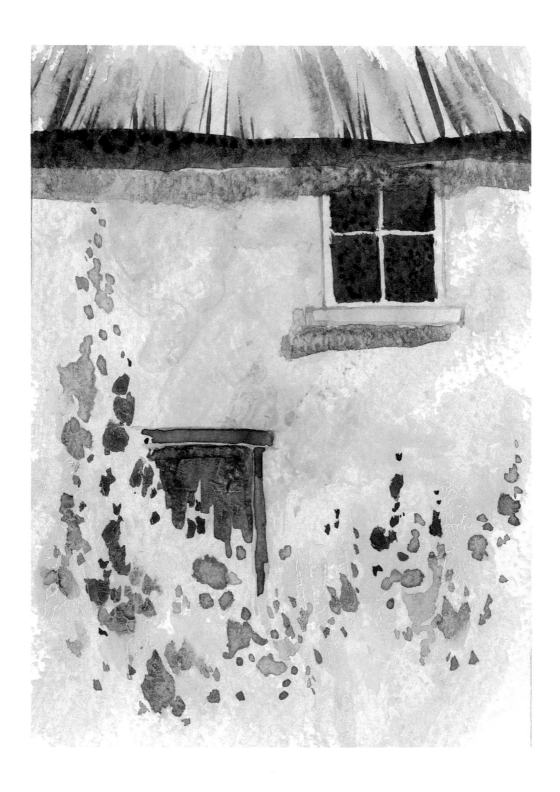

You will need:

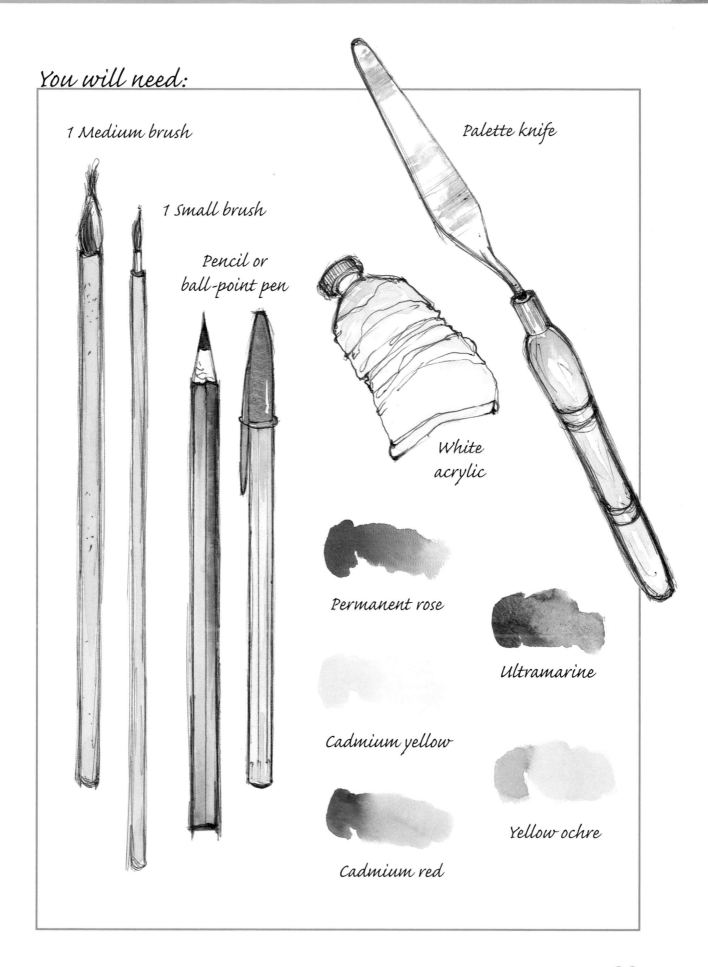

1 Medium brush

1 Small brush

Pencil or
ball-point pen

Palette knife

White
acrylic

Permanent rose

Ultramarine

Cadmium yellow

Yellow ochre

Cadmium red

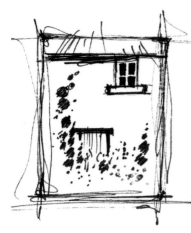

PLANNING YOUR PAINTING

Begin by using a pencil or ball-point pen to plot out the placement and proportions that you would like for your painting in a thumbnail sketch.

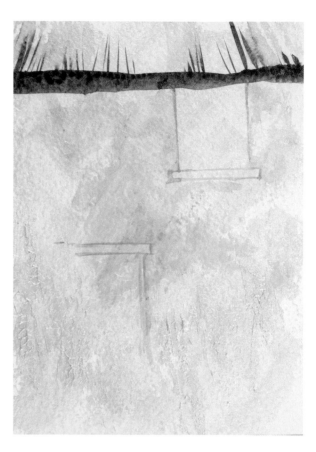

PAINTING THE BACKGROUND

Use a suitable piece of card or an old photograph as a template to mark a rectangle on your paper. Mix a small amount of white acrylic paint with a little yellow ocre on a scrap piece of paper or card using a palette knife. Continue using the palette knife to cover the entire surface. Dab the acrylic with the flat part of the palette knife to create texture then allow the paint to dry before moving on to Stage 2.

2 POSITIONING THE ROOF, WINDOW AND DOOR

Create a puddle of dark colour using ultramarine with some cadmium red. Paint the edge of the thatched roof using a medium brush. Keep the roof line very close to the top of the composition (it is a good idea to refer to your thumbnail sketch for positioning here). Lightly paint some near-vertical lines using the dark colour to show the thatched roof. Mix a very thin cadmium red puddle then use a very small brush to lightly paint in the outline of the window and window sill. Partially paint the door-frame, then put more lines on the thatched roof. Using the same brush and colour, apply it in a circular motion to create an interesting texture for the wall as the brush runs out of colour. This is called 'dry brushing'.

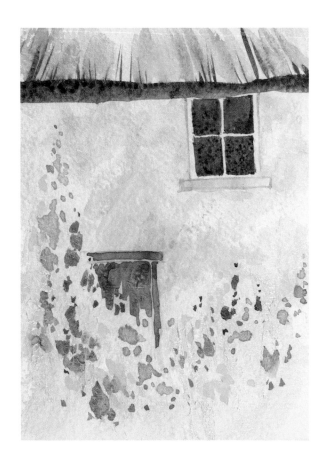

3 PAINTING THE WINDOW, GARDEN AND DOOR DETAILS

Using a small brush and the same dark colour created in Stage 2, paint four small rectangles inside the window area leaving a small gap all the way around. All five colours and both brushes can then be used to create flowers and shrubs in the garden area following a natural 'v' shape. Create two brown colours using cadmium red with different amounts of ultramarine. Choose one brown to use for the door and another for the door frame. Use all the colours to paint the thatched roof. Dry the paper.

4 SHADOWS

Create a pale watery ultramarine with the small brush. Use this colour to paint shadows under the eaves, under the window sill and across the top of the door. Add some of this blue to the flowers.

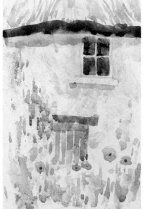

Try some variations on the same composition

Techniques for Trees

This painting combines horizontal and vertical stroke
techniques to create trees in pencil complemented
by watercolour backgrounds

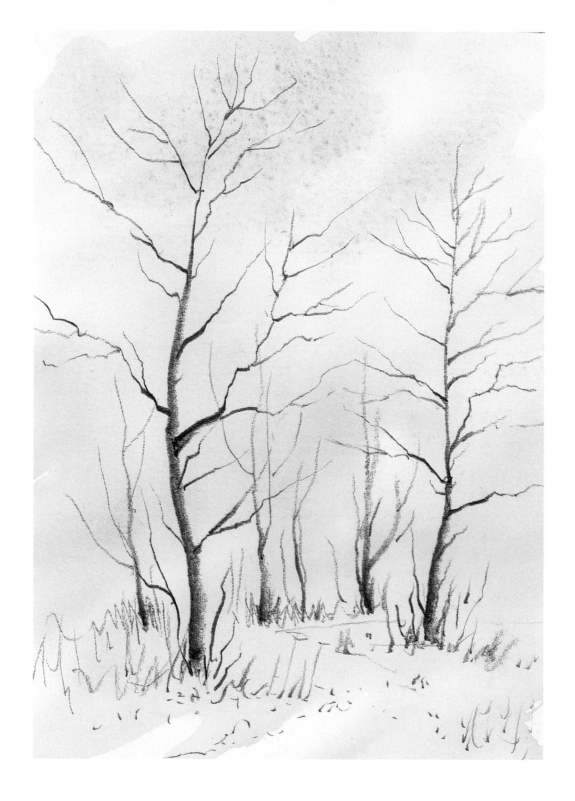

You will need:

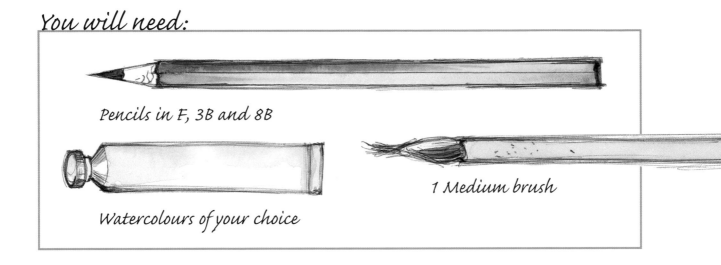

Pencils in F, 3B and 8B

Watercolours of your choice

1 Medium brush

PRACTISING YOUR TECHNIQUE

It is a good idea to practise drawing the trees before you begin your final composition.

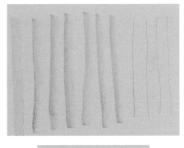

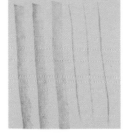

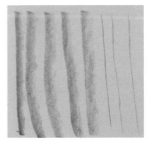

Horizontal technique

Hold the pencil near the tip and lay the whole of the graphite on the paper. Push the graphite upwards to make a wide mark that is dark on one side and fades out on the other. This gives the effect of a tree trunk with one side in dark shadow. To get the feel of this grip, practise making short marks without altering the grip or the pressure on the paper.

Vertical technique

Hold the pencil in the same grip near its tip with all the graphite touching the paper, but move it to a vertical position. Push the pencil upwards. To taper the mark off at the top of the tree, lift the graphite so that only its tip is being pushed upwards.

Controlling the pencil

Practise using different grades of graphite pencil, drawing both horizontal and vertical marks. A flat edge will develop on your graphite surface improving the wide 'tree trunk' stroke. The thin vertical mark creates a twig.

THE TREE TRUNK

Make a broad line, changing the angle of the pencil from horizontal to vertical without removing the pencil from the paper. This will create a tree trunk effect. Add a few pencil dots to indicate how far the branches and twigs need to go to show the shape of the tree.

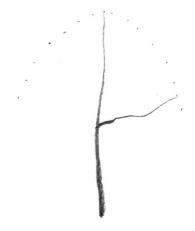

2 DRAWING THE FIRST BRANCH

Draw the first branch about one third of the way up the tree trunk. Holding the pencil vertically move it sideways out from the edge of the tree trunk to the outline of the tree indicated by the points. Turn the pencil so that you are pushing it to a tapered edge to create a twig effect at the end of a branch.

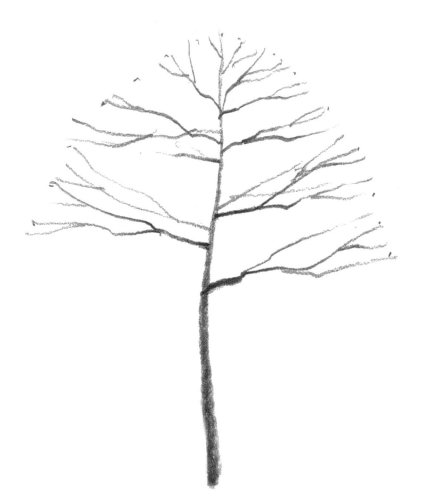

3 ADDING MORE BRANCHES

Repeat this process, making each branch smaller as they move up the trunk. Ensure that you offset the branches so that the tree does not look too symmetrical, as shown here, and make each one slightly different.

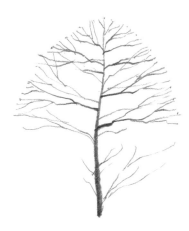

4 TWIGS
Create a twig effect by adding further small marks to fill some of the empty spaces around the outer branches. Add small twigs to the end of the branches.

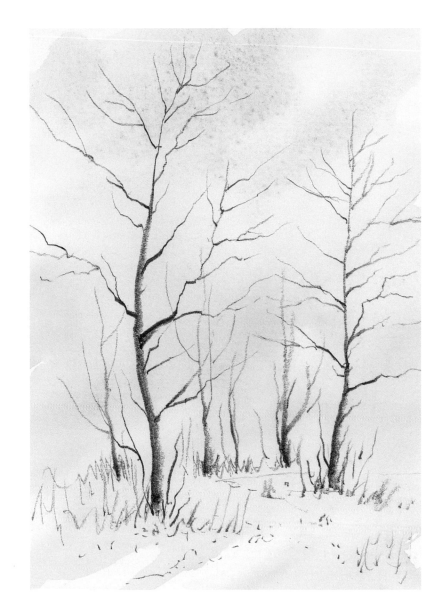

5 BACKGROUND
For the completed painting, the background is created first, using the wet-on-wet technique and your choice of colours. When the paint is completely dry, draw various sizes of trees using different grades of graphite pencil.

Indigo Sky

This painting is gradually built up over six stages

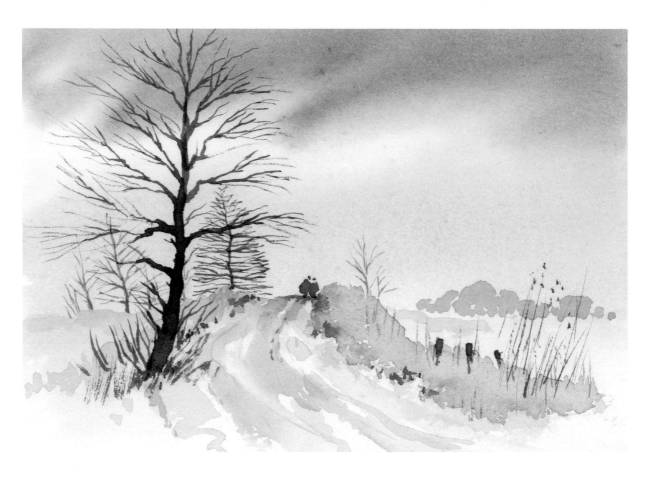

You will need:

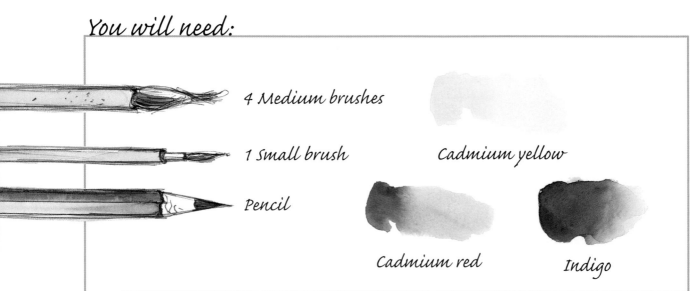

4 Medium brushes

1 Small brush Cadmium yellow

Pencil

Cadmium red Indigo

PLANNING YOUR PAINTING

Use the photograph shown here or a similar one of your own as a reference from which to make a thumbnail sketch and practise painting small people and trees. It is also helpful to experiment with your colour mixes before you begin, as this painting works with a varied colour palette.

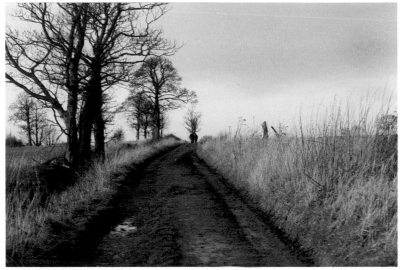

Make a thumbnail sketch from a photograph

Practise sketching small people and trees

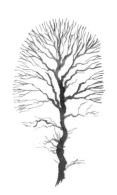

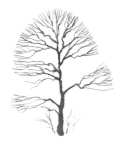

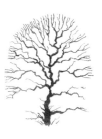

1 BACKGROUND COLOUR

Pencil out a rectangular border for your painting. Using three medium brushes – one for each colour – make puddles of indigo, cadmium red and cadmium yellow. With the fourth clean brush wet the paper. Tip off the excess water then drop in indigo at the top, cadmium red in the middle and cadmium yellow at the bottom. Dry the paper.

2 ADDING INITIAL DETAIL

Using a medium brush, mix a medium brown puddle with cadmium red, a little indigo and a lot of water to paint a pale road. Keeping the next wash equally thin, mix a pale puddle of cadmium yellow and use this to paint a field on either side of the road. Dry the paper.

3 ENHANCING THE COLOUR OF THE ROAD

Add an orange hedge on either side of the road with darker brown edges next to the road. Place distant trees on the right-hand side in a pale watery indigo mixed with a little cadmium yellow. Lighten the green with a little more cadmium yellow and add some green either side of the road. Dry the paper.

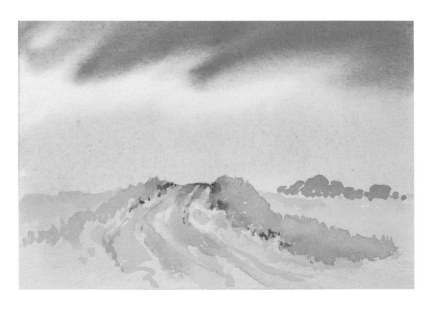

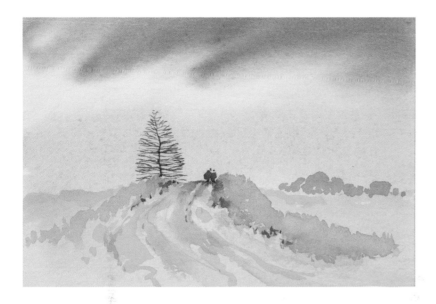

4 POSITIONING TREES AND PEOPLE

Use a strong indigo or a mix of indigo and a little cadmium red to paint the trees and people. With the small brush paint the tree just beyond the horizon and the people on the horizon to draw the eye into the picture.

5 ADDITIONAL DETAIL

Using the same dark colour and small brush add more trees in the distance, as well as a fence and grasses.

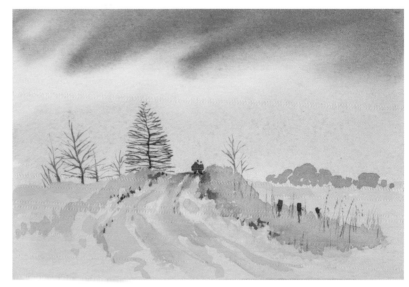

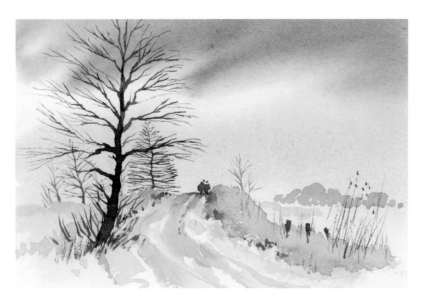

6 ADDING THE LARGE TREE

Practise painting the largest tree on a separate piece of paper first, until you are confident about adding it to your final picture. Use the same dark colour used in Stages 4 and 5, and paint the trunk of the tree using a medium brush and the branches and twigs using a small brush. Add the large tree to the left side of the road.

Brushmarks for Flowers

Paint a burst of colour using a simple brush technique
to create petals on a vibrant group of flowers

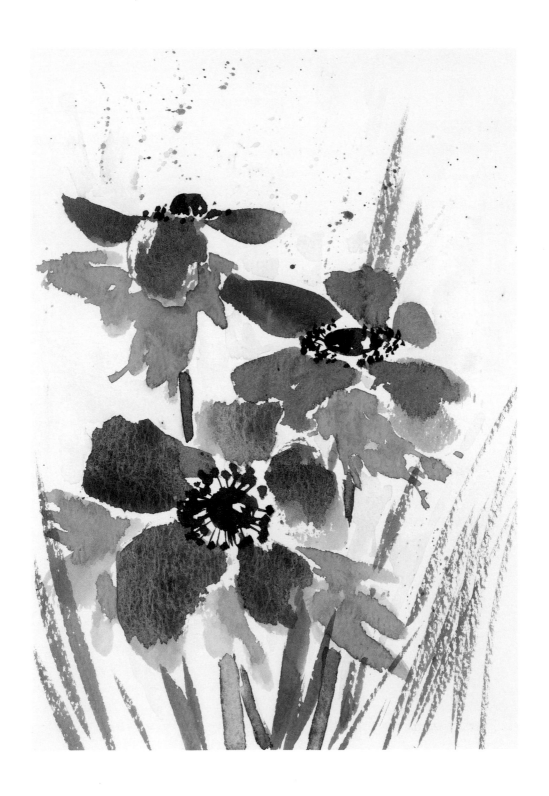

You will need:

1 Large brush

1 Medium brush

1 Small brush

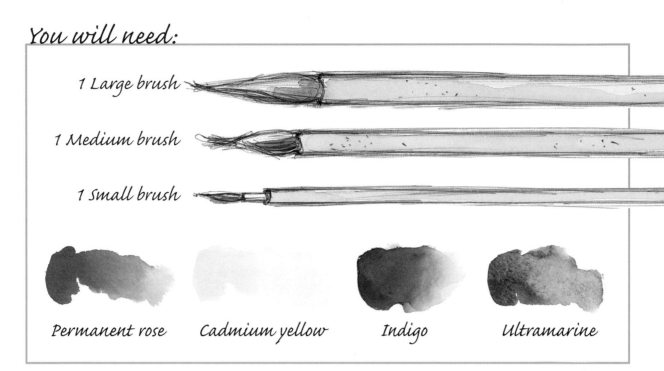

Permanent rose Cadmium yellow Indigo Ultramarine

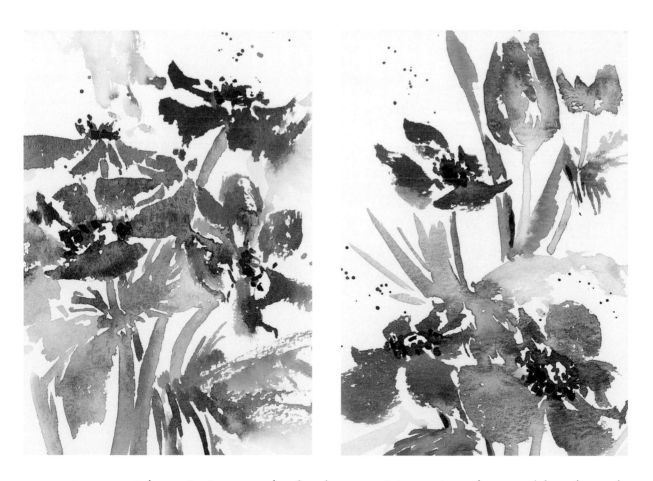

Experiment with variations on the final composition using the petal brushmarks

CONSTRUCTING THE FLOWERS

Position the centres of the flowers carefully, allowing space for petals around each. Load the brush for an intense colour and move it firmly in different directions for each petal so that each one is slightly different in shape and size.

Practise mixing different proportions of two colours

Ultramarine + permanent rose *Indigo + permanent rose* *Indigo + cadmium yellow*

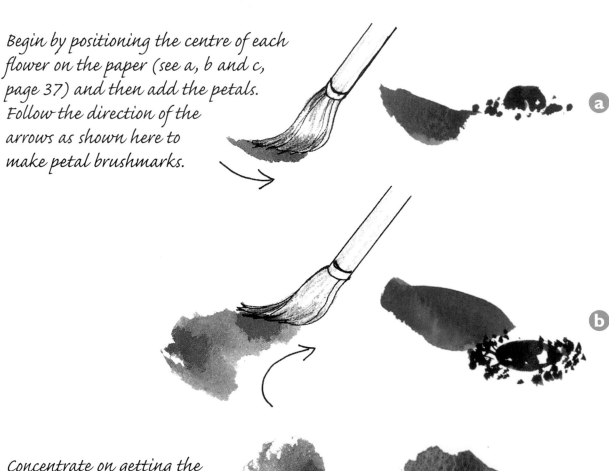

Begin by positioning the centre of each flower on the paper (see a, b and c, page 37) and then add the petals. Follow the direction of the arrows as shown here to make petal brushmarks.

a

b

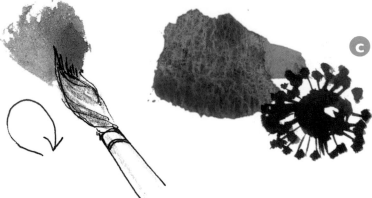

Concentrate on getting the shape of the flower right as you add the petals one by one

c

2

2 ADDING THE LEAVES AND STALKS

Once the flowers are complete, shape the leaves around them. Paint in the stalks using contrasting colours to the leaves. Complete the painting with extra leaves to balance the composition and fill the space. I have also used paint splashes here to suggest movement and background detail.

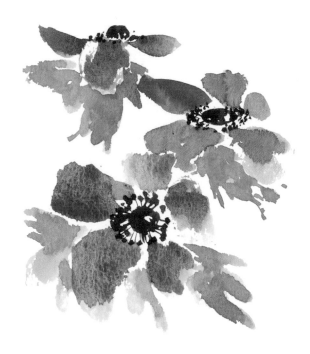

Add the leaves around the flowers

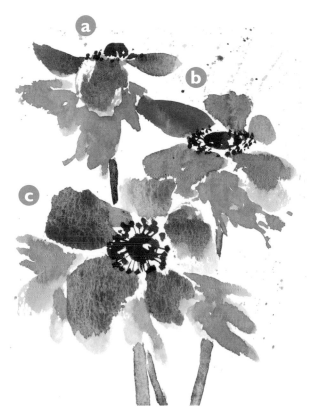

Then add the stalks

Complete the picture with grasses and some scattered dots of colour

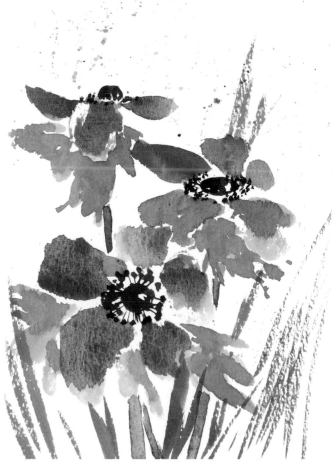

Cottage in the Mountains

Learn how to do a sketch over a random tint

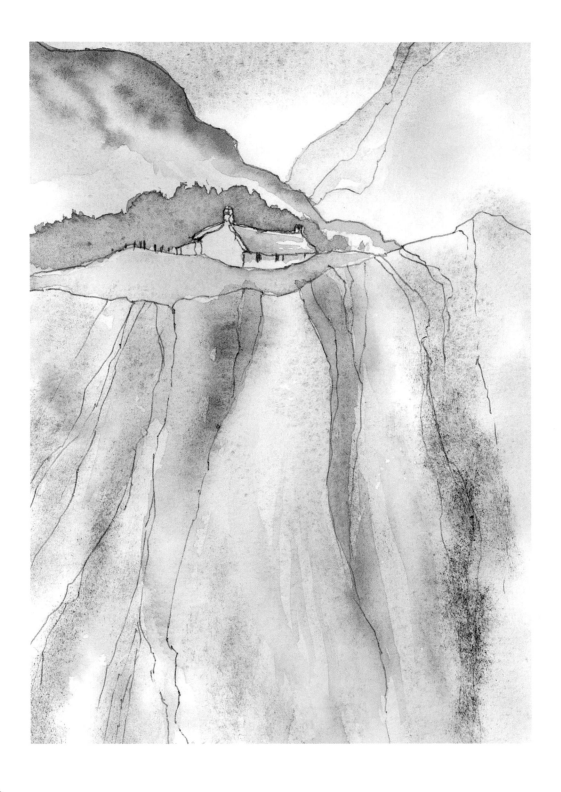

You will need:

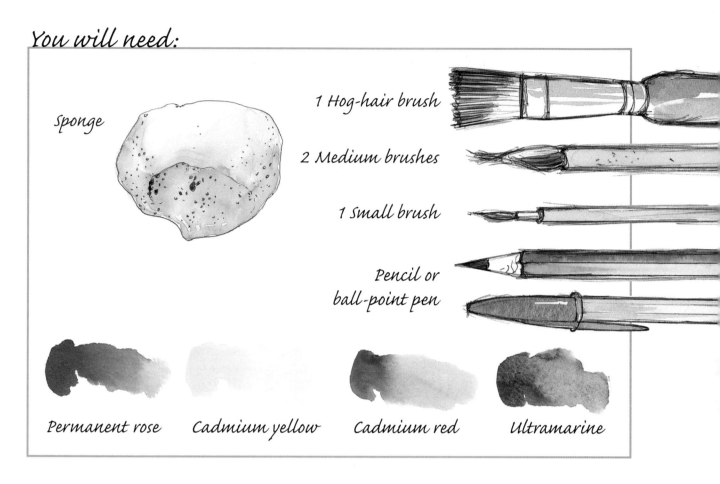

Sponge

1 Hog-hair brush

2 Medium brushes

1 Small brush

Pencil or
ball-point pen

Permanent rose Cadmium yellow Cadmium red Ultramarine

TINTING THE PAPER

Using a medium brush, prepare watery puddles of cadmium yellow, ultramarine, permanent rose and cadmium red. Use the other medium brush to wet the paper. Gather the excess water to a corner and dab with a paper towel. While the paper is still wet apply small amounts of each colour similar to the sample shown here. Start with the cadmium yellow, cleaning the brush each time you change colour. The effect created by building up the colour in this way is called a 'random tint' and can be used for backgrounds.

2 SKETCHING THE PICTURE

After drying the painting use either a graphite pencil or a ball-point pen to mark the picture details. Draw the cottage about one third of the way down the picture. Position the foreground close to the roof edge. Create curved lines for the mountains and more irregular lines for the cliff face.

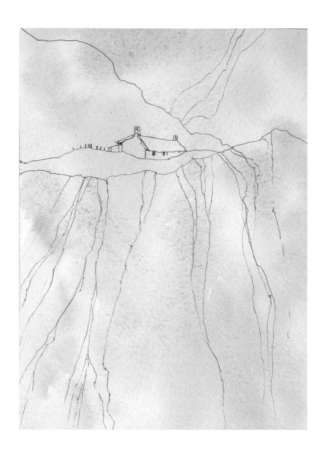

3 ADDING DETAILS

Paint the trees behind the cottage with a green made from cadmium yellow and ultramarine. Take a clean brush and drop in some water to watermark them. Paint the roof using a small brush and a weak cadmium red colour. Add some yellow to the medium green mix in the palette and paint the grass with a small brush, adding some slightly stronger green just in front of the cottage.

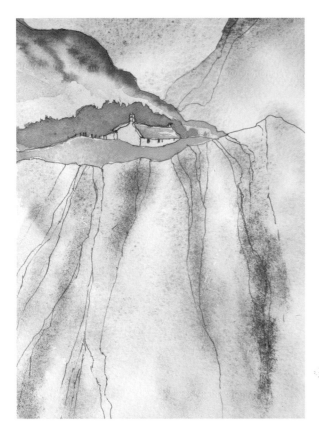

4 ADDING TEXTURE

Mix a purple with ultramarine and a little permanent rose. Create texture on the cliffs: either a rough texture by using a natural sponge to collect a small amount of paint and dabbing this gently on the paper; or a finer texture by using a hog-hair brush vertically. Mix another purple with permanent rose and a little ultramarine, then re-wet the mountain behind the trees and dab this purple to the top edges of the paper. Slightly re-wet the distant mountain on the right-hand side and add a small amount of ultramarine to part of it. Dry the paper.

Create a rough texture with a sponge

Create a smoother texture using a hog-hair brush

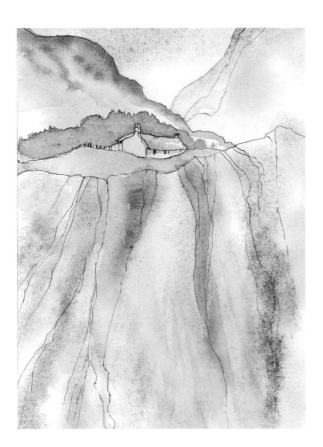

5 ADDING HIGHLIGHTS AND SHADOWS

Using the small brush, add a watery cadmium yellow to the cliff-face and the distant mountain on the right-hand side. Still using the small brush, add an ultramarine line of shadow under the eaves of the cottage roof. After the cadmium yellow has dried, use a medium brush with some watery ultramarine and add this to some of the vertical areas of the cliffs. Stipple some ultramarine on the cliff-face using the hog-hair brush.

Winter Sky

Use a background of winter sun to add drama
to these silhouetted trees

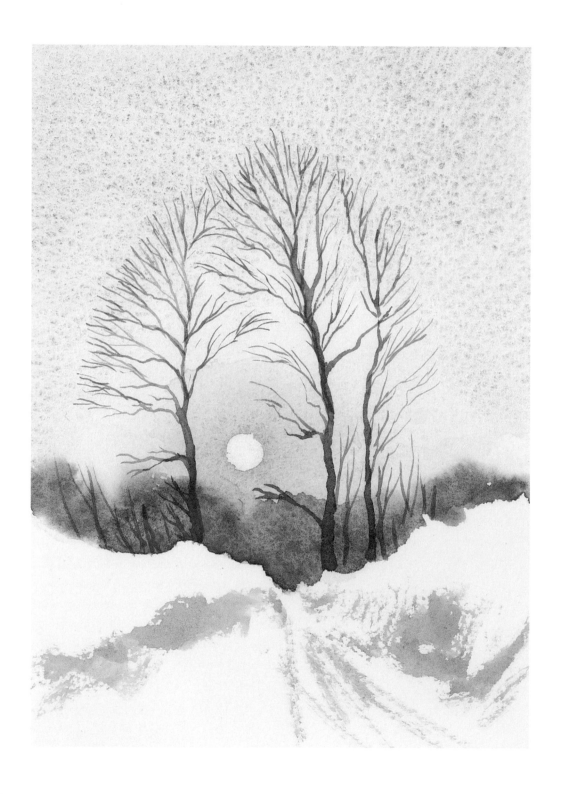

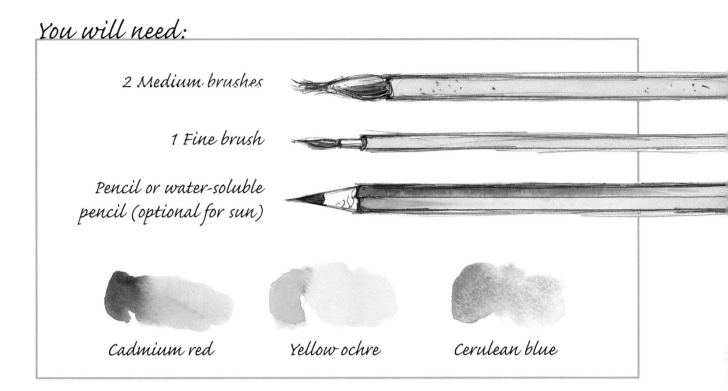

You will need:

2 Medium brushes

1 Fine brush

Pencil or water-soluble
pencil (optional for sun)

Cadmium red Yellow ochre Cerulean blue

PAINTING THE SKY

Before wetting the paper, use a small brush and
a little yellow ochre to dot in the snow line. Wet the
paper above the snow line with a medium brush.
Gather the excess water into a top corner and then
dab with a paper towel. Paint the sky using the two
medium brushes, one for watery yellow ochre and
one for watery cerulean blue. Dab yellow ochre in
the centre and cerulean blue on the outer edges. Tilt
the paper to blend the colours and gather the excess.
Continue with Stage 2 while the paper is still damp.

2 ADDING THE SUN

The sun should be added just beyond the snow bank so that the eye is drawn in to it. There are two methods for producing your sun. The first (right) involves lifting the colour off after it has dried. Dab a damp paper towel through a circular stencil to lift off the yellow paint. The second method (shown below) is to use a stencil to draw a sun in pencil onto dry paper, this can be done using an ordinary or a water-soluble pencil.

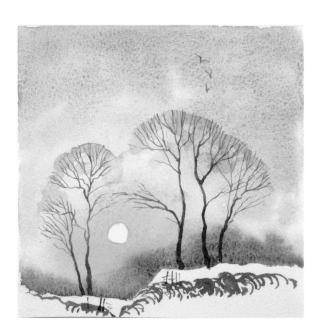

Here a stencil was used to draw a circle for the sun in pencil then the sky was painted around this shape

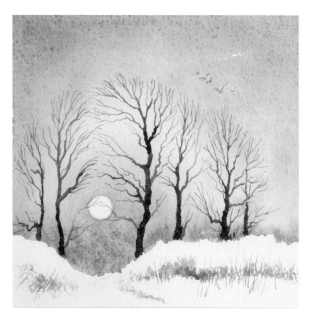

Again, a stencil has been used for the sun. This time a water-soluble pencil was used, which dissolves with the wash

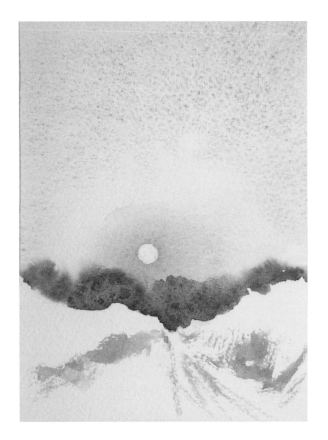

Practise painting the trees using a small brush and a stronger dark colour (some cadmium red and a lot of cerulean blue). Make groups of trees using those shown below as a guide. Paint the trunks first, then use a small brush with very little paint to add smaller branches.

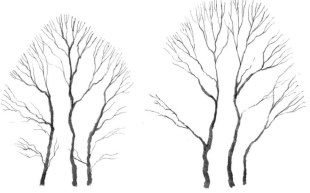

Practise painting trees before adding them to your final picture

3 PAINTING THE DISTANT TREES

Use a medium brush to make a rich dark colour with some cadmium red and a lot of cerulean blue to paint the distant trees. Dampen the area above the snow line before adding the distant trees and tilting your paper toward the sky to roll the colour a short way. With a small dry brush pick up some of the same dark colour from the trees in order to add shading to the snow banks using a dry brush effect. Dry the paper.

4 PAINTING THE LARGE TREES

Using a small brush and the same dark colour already used to practise painting trees, paint the whole of the tree group. Encircle the sun with the branches and twigs using a partly loaded brush for the branches, and continuing to paint the finer twigs in the same stroke. The branches and twigs of each tree can now be extended to form an interesting contour of a group of trees.

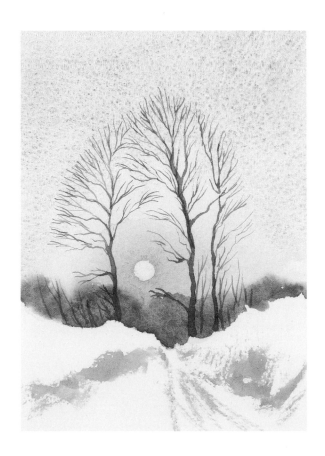

Sunset by the Lake

This mountain and lake composition will teach you how
to create effective reflections and water effects

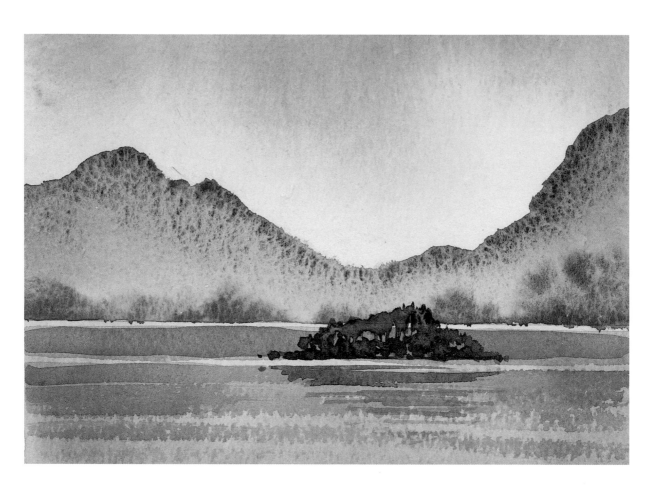

You will need:

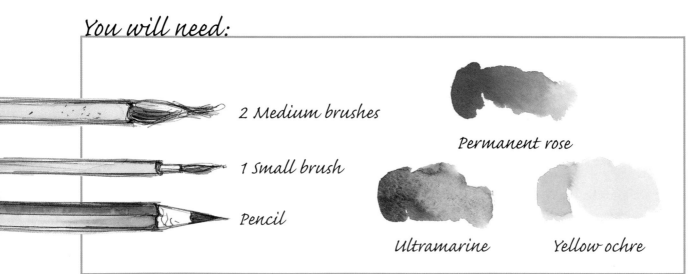

2 Medium brushes

1 Small brush

Pencil

Permanent rose

Ultramarine

Yellow ochre

*Using the same techniques,
experiment with different colours
and compostions*

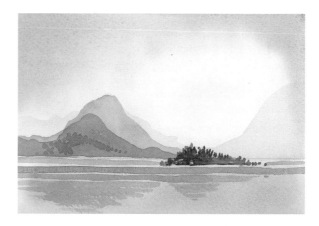

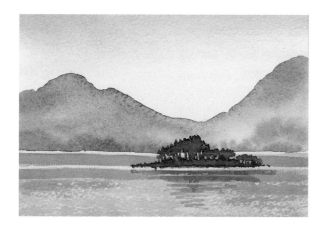

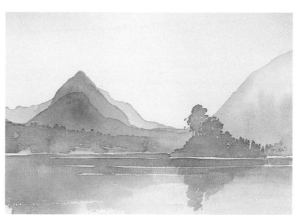

TINTING THE PAPER

Use a medium brush to prepare watery puddles of yellow ochre and permanent rose. Use the other medium brush to wet the paper then gather the excess water into one corner and dab with a paper towel. Apply yellow ochre all over the paper and permanent rose to the top and bottom. Dry the paper.

2 ADDING THE MOUNTAINS

Draw a light pencil line as a guide for the water's edge. Wet the mountain shape with a medium brush, apply a watery ultramarine to the top edge of the mountains, keeping the paper flat. The ultramarine will make a hard edge and will blend into the wetness. Watery puddles of the other two colours can be applied freely wet into wet on the mountain shape. While the mountain shape is still wet, make a strong green using yellow ochre and ultramarine and paint the trees using a small brush. Dry the paper.

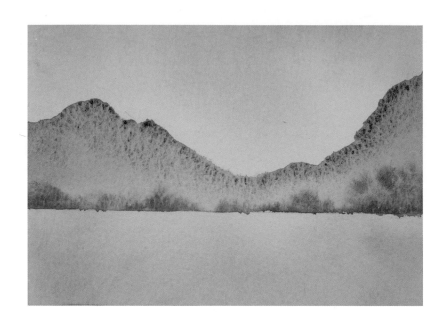

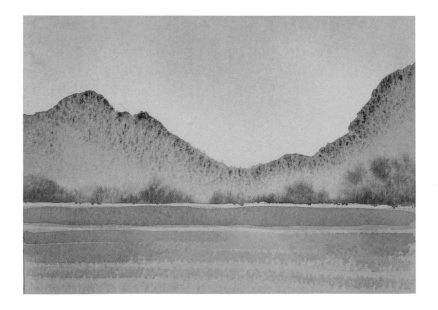

3 PAINTING REFLECTIONS

Partly load the medium brush with a watery ultramarine. Apply brush lines across the water by dragging the brush head horizontally in one direction. As the brush runs our of colour, the effect achieved will be a speckled dry brush. Dry the paper. Mix a purple with ultramarine and permanent rose, then repeat the process one more time. Dry the paper again.

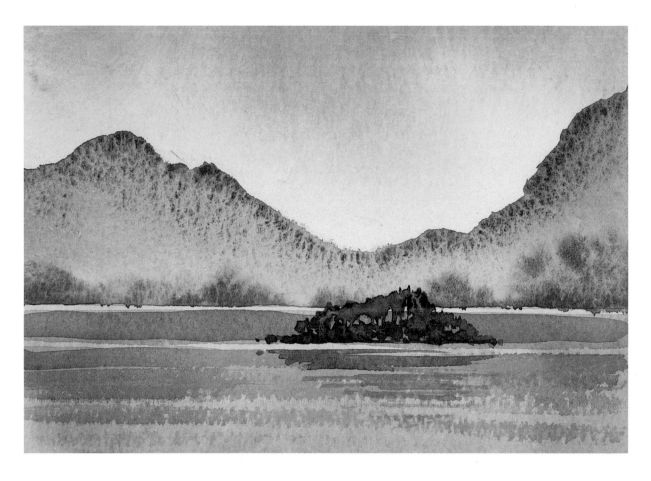

4 ADDING THE ISLAND

Mix a dark colour puddle for the island from ultramarine with some permanent rose and a tiny amount of yellow ochre. Practise painting the island shape using a small brush, starting with the base of the island, then dab on the foliage and connect the two together with the tree trunk lines (see enlarged version, right). Once you are happy with your island add it to the final composition, positioning it slightly off-centre. While the paint on the island is still wet, dab on some water to create a watermark. Still using the small brush, water down the dark colour and paint horizontal lines for the island reflection. Dry the paper.

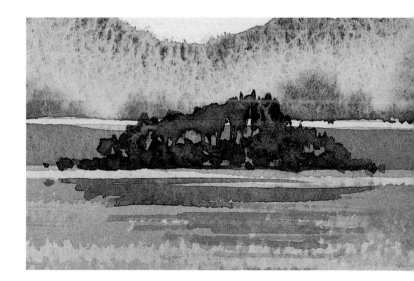

Poppies by the Window

This picture combines brushmarks for the
poppies and ball-point pen for the detailing

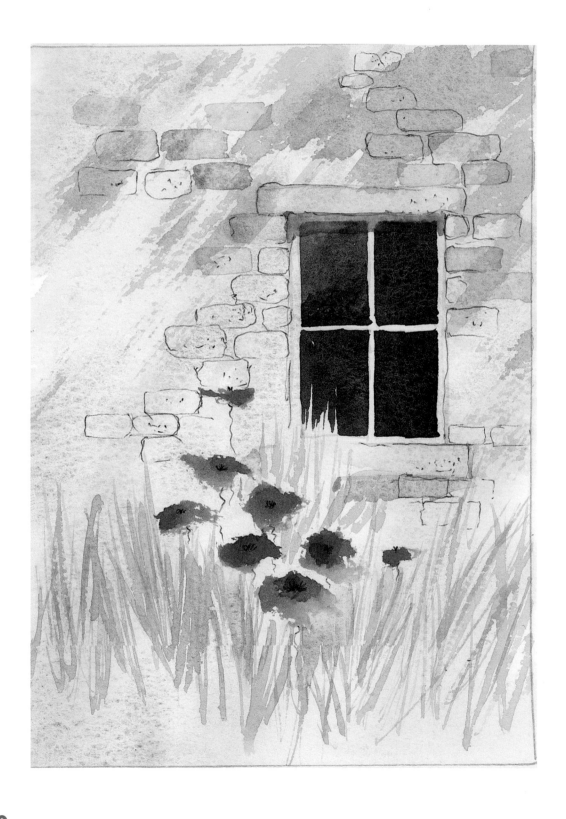

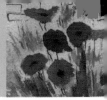

You will need:

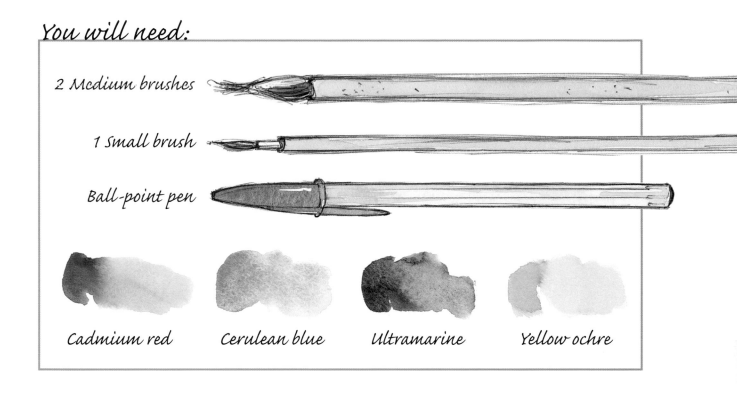

2 Medium brushes

1 Small brush

Ball-point pen

Cadmium red Cerulean blue Ultramarine Yellow ochre

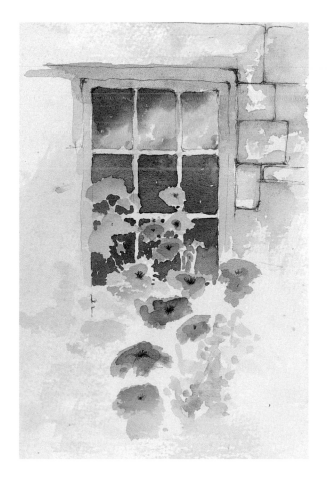

This variation has been painted in a similar way, but with a less dense mix of paint on the window panes

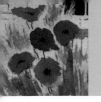

 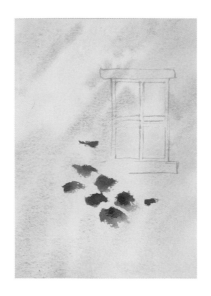 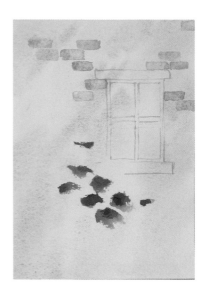

1 TINTING THE PAPER

With a medium brush prepare watery puddles of all the colours. Use the other medium brush to wet the paper. Gather the excess water to a corner and dab with a paper towel. While the paper is still wet, apply small amounts of each colour in one slanting direction. Clean the brush between each application of colour. Dry the paper.

2 BEGINNING THE WINDOW AND THE POPPIES

Use cadmium red to practise painting poppies with one brushstroke then adding detail with a ball-point pen. Add the poppies to your background. Decide upon a style of window (see examples below) and using a small brush outline the shape with yellow ochre. Dry the paper.

3 ADDING THE BRICKS

Using the small brush, prepare weak puddles of all the different colours. Paint brick shapes around the outside of the window. Drop a small amount of water onto each brick as you paint it to lighten the flat colour and outline the shape. Add yellow ochre to the window lintel and edge.

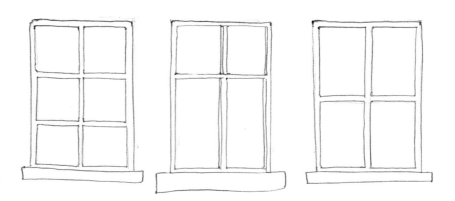

Some ideas for simple windows

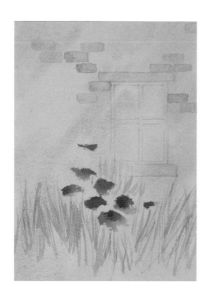

4 THE GRASS

Create a range of different greens using yellow ochre with cerulean blue. Paint the grass with upward strokes using the small brush. Dry the paper.

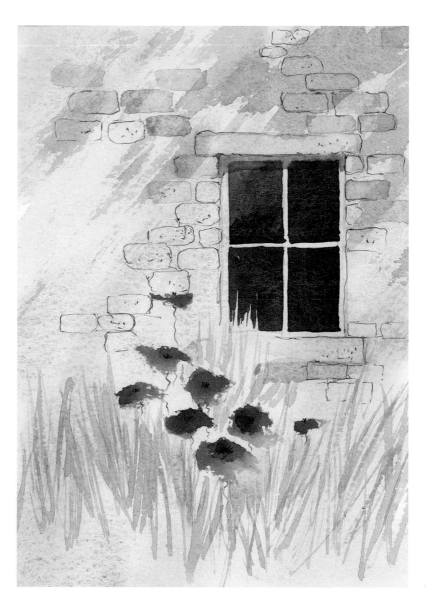

5 DARKS AND SHADOWS

Mix a strong dark colour using ultramarine with some cadmium red and paint the window panes using the small brush. Let the paper dry completely before using the ball-point pen to draw in additional bricks. Continue using the ball-point pen to draw in the flower stalks and centres. Make a weak puddle of ultramarine and using the medium brush paint a shadow across the top of the window and under the window sill. Continue with the same colour and brush to paint the shadow detail under the flowers. Paint angled strokes to cast the shadow on the building above the window.

Broken Wall

This project uses a wet-in-wet wash to create a random tint that
is then gradually built up using stronger colours and lines

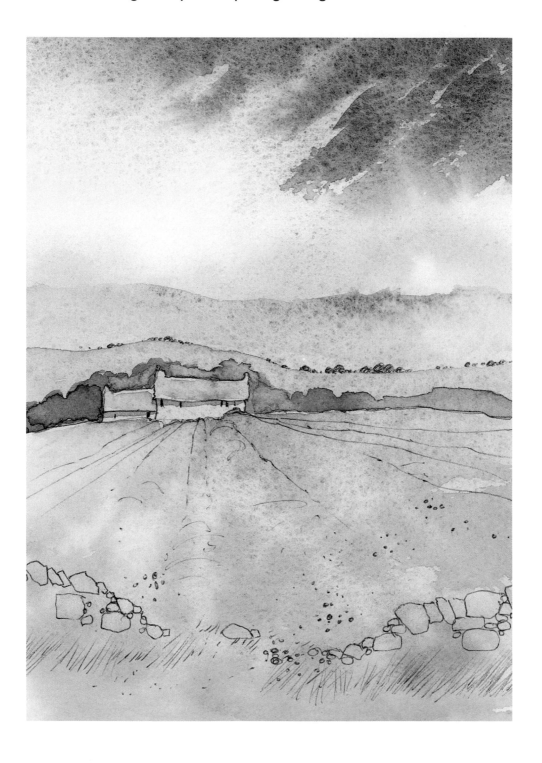

You will need:

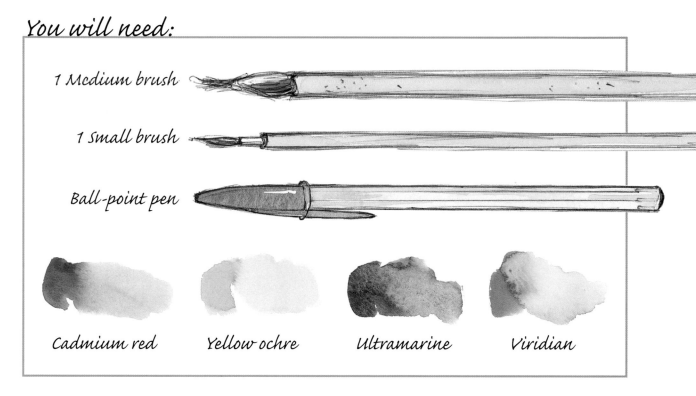

1 Medium brush

1 Small brush

Ball-point pen

Cadmium red Yellow ochre Ultramarine Viridian

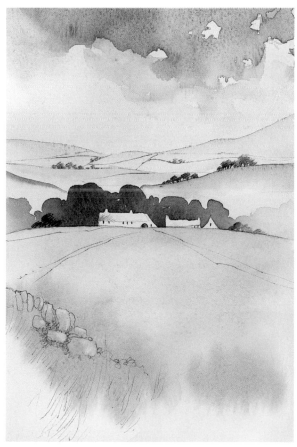

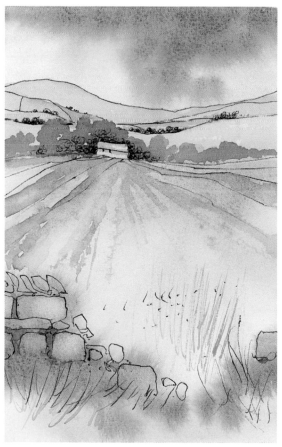

Two variations on the theme, worked using the same techniques

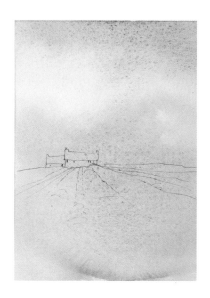

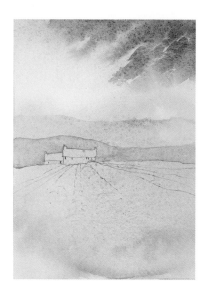

1 **WET-IN-WET WASHES**
Using all four colours as fairly weak watery puddles, wet the paper with the medium brush and apply each colour in turn – yellow ochre, cadmium red, viridian and ultramarine – from the bottom to the top. Dry the paper.

2 **FIRST PEN MARKS**
Decide upon a style of cottage that you'd like to feature in your painting (see below for ideas). Use a ball-point pen to draw in the field edge horizon, then the cottage, then draw all the field lines so that they point towards the cottage in order to draw the eye in towards it. Practise drawing a variety of cottage shapes before you choose one that is suitable for your final composition.

3 **ADDING MORE DETAIL**
Using the small brush paint yellow ochre behind the cottage. Before it dries add some water and turn the paper upside down to create a watermark on the top edge of the yellow ochre and allow it to dry. Wet the sky area. Make a purple mix of ultramarine with a little cadmium red and dab this mix into the top of the sky. Wet the foreground and using the same purple dab this colour roughly where the stones will be drawn. After the sky has dried, paint an ultramarine area just above the yellow ochre. Add some water and turn the picture upside down again to make another watermark.

Cottage shapes to practise

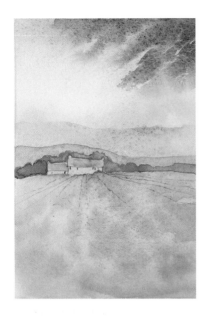

4 ADDING MORE COLOUR

Using the small brush, mix viridian with a little yellow ochre and paint a line of trees behind the cottage. Drop a little water into this area to create a watermark. Dampen the whole area below the cottage and add the viridian mix at the bottom of the field. Make a small watery puddle of cadmium red and position this at the top of the wet area. Put a small amount of yellow ochre on the roof. Dry the paper.

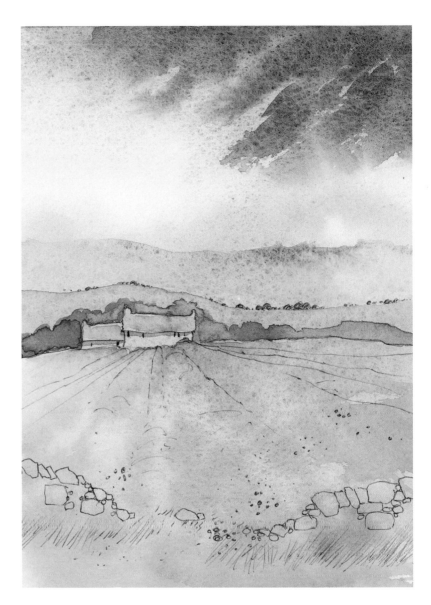

5 ADDING DETAIL WITH BALL-POINT PEN

Make small marks for the distant trees, small dots for field texture, long sweeping marks for the foreground grasses and carefully shaped marks for the stones in the wall. To highlight the rocks, put a small amount of water on one side of a rock, rub this area with a small brush and dab it with a paper towel to lift off some colour. Finally, using the small brush and some watery ultramarine, paint in the tiny eaves shadow on the cottage.

Evening Glow

This atmospheric picture combines pencil tone with
overlaid watercolour washes

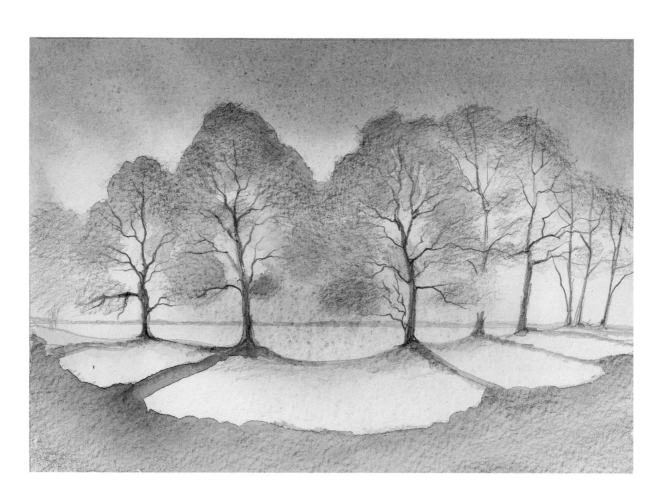

You will need:

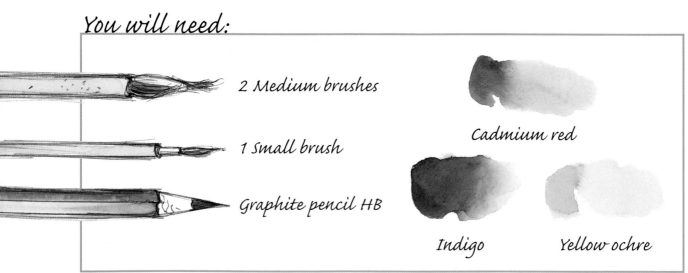

2 Medium brushes

1 Small brush

Graphite pencil HB

Cadmium red

Indigo

Yellow ochre

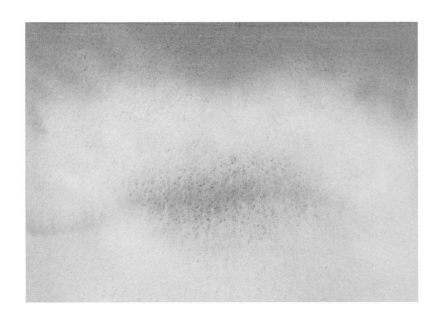

I TINTING THE PAPER
Make watery puddles of
each colour. Wet the paper and
collect the excess water with a
paper towel. Apply watery yellow
ochre across the middle of the
paper then strengthen the puddle
and apply it at the bottom.
Apply cadmium red in the
centre and indigo across the top.
Dry the paper.

2 SKETCH THE TREES
Mark a horizontal line and
apply a small amount of graphite
pencil for the distant hills.
Draw in a curvy line to indicate
a ridge on which the trees will
be positioned. Pencil in the tree
trunks using a crosshatch
technique – shading areas by
drawing sets of parallel lines in
different directions. If done using
the side of the pencil it is an
effective way to shade large
areas quickly. Pencil in the tree
foliage leaving gaps to add
interest and depth.

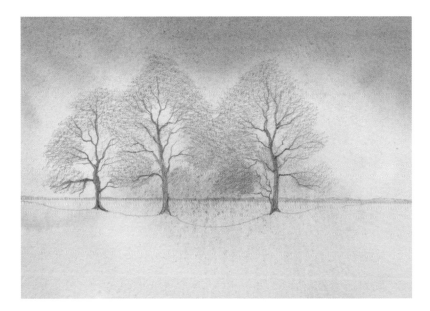

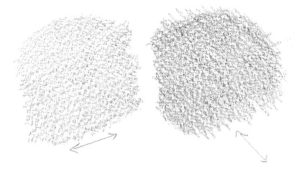

*Move the side of the pencil in one direction,
then make another layer in another direction, in
order to build up tone. This is called crosshatching*

3 COMPLETING THE TREES

Continue across the page making the rest of the trees smaller and unequally spaced. Keep the base of the trees somewhere on the curvy line.

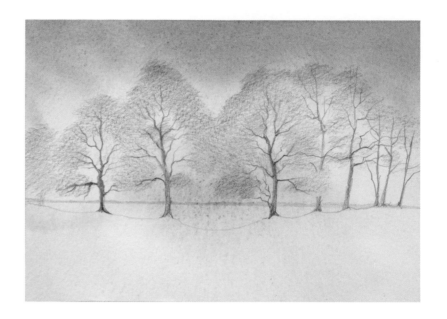

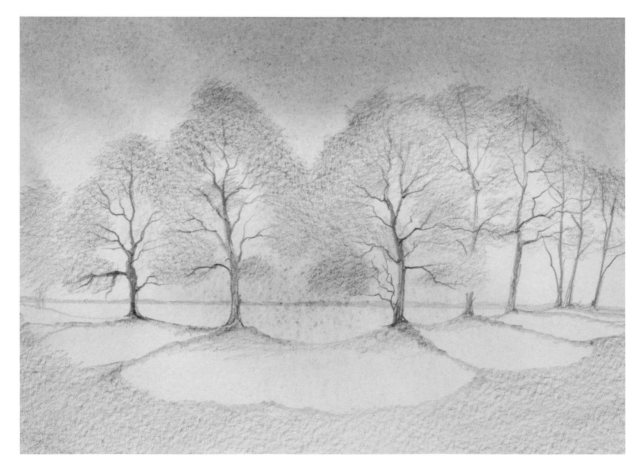

4 SHADOW DETAIL

Using the same graphite pencil and the crosshatch technique, mark in the shadows of the trees on the ground, being careful to get the angles of the trunks correct.

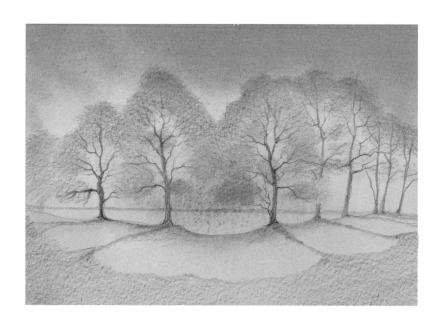

5 PAINT THE TREES

Mix a small amount of watery cadmium red. Apply this to the edges of the foliage of the trees. Using the small brush and the same colour, paint a yellow ochre edge underneath the curvy tree line. Dry the paper.

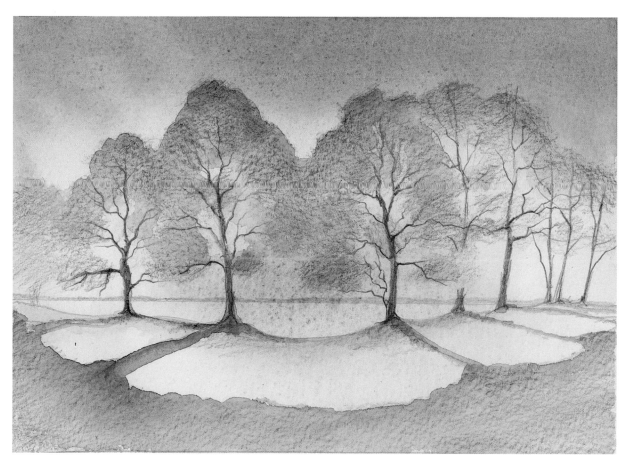

6 STRENGTHENING DARK AREAS

Make a watery puddle of indigo and mix a little cadmium red into it and use this colour to gradually build up the dark areas of the trees and shadows. Dry the paper.

First Snow

You can paint a whole range of scenes from a basic
monotone landscape by adding some simple elements
and a limited amount of colour

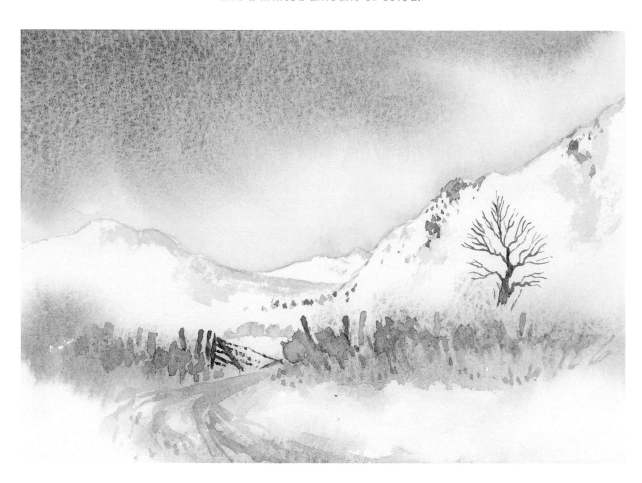

You will need:

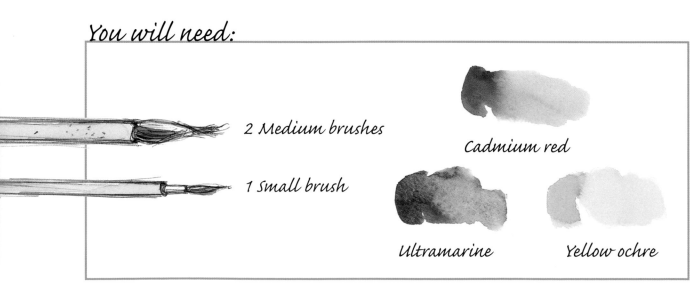

2 Medium brushes

Cadmium red

1 Small brush

Ultramarine Yellow ochre

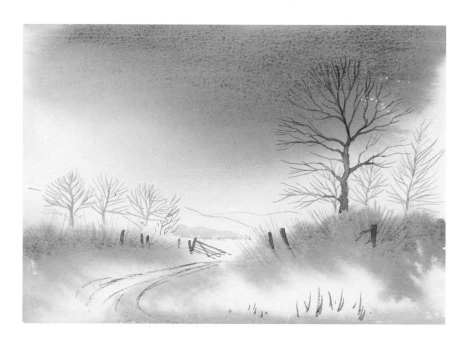

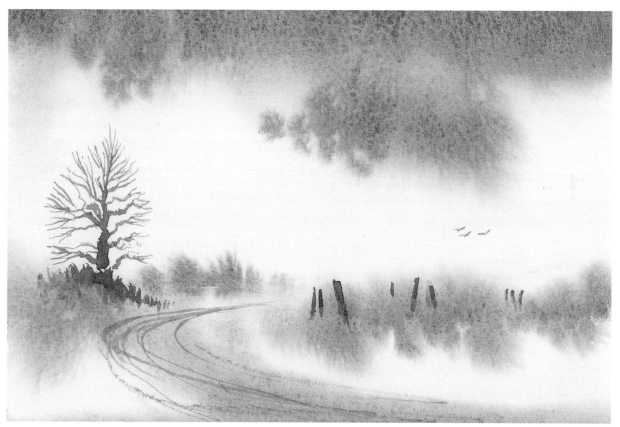

*These two variations show some of the basic
landscape elements (distant trees, clouds, hedges
and path) but use only one colour mix*

Make a thumbnail sketch as a guide for the larger picture

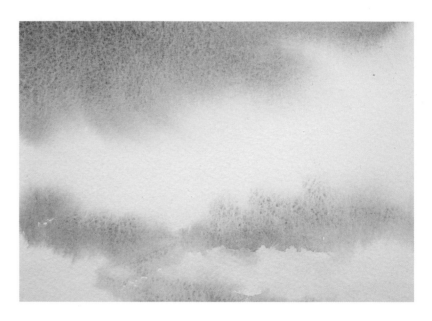

POSITIONING THE COLOUR

With the medium brush, mix a large puddle of ultramarine with a very small amount of cadmium red. Using the second medium brush wet the paper and gather the excess water onto a paper towel. Position the paint in four areas: the sky, the two separate hedgerows, and the pathway. Dry the paper.

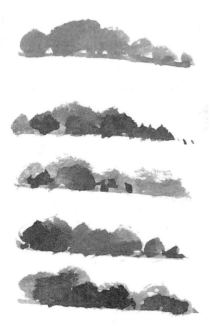

Practise painting tree shapes before you add them to your picture

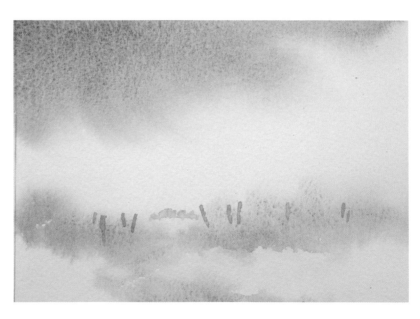

2 ADDING THE DISTANT TREES AND FENCE POSTS

Using the same colour practise painting shapes for distant trees (see left). Paint small trees above the pathway and in between the hedgerows. Dry the paper. Using the small brush and the same colour, paint small fence posts in an uneven line. Dry the paper.

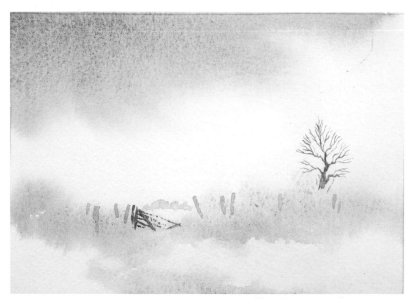

3 ADD A GATE AND TREE

This basic illustration can be enhanced in various ways — by adding small details the scene can be given greater depth. Using the same colour mix but with less water, paint part of a broken gate and a bare winter tree. This could be your final painting.

4 ADD A MOUNTAIN

Using a very watery ultramarine, paint a thin line for the mountain shapes and add a very watery yellow ochre to the sky just above the mountains.

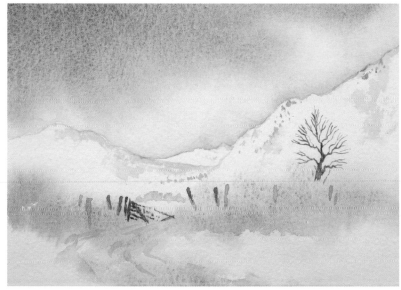

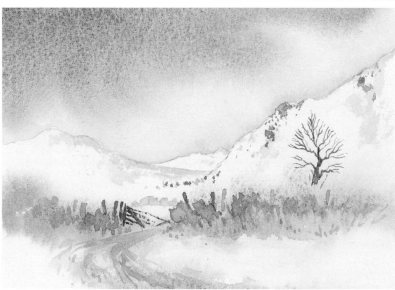

5 ADD COLOUR

Mix cadmium red with some ultramarine and use this for the hedgerow and the pathway. Paint watery ultramarine on the mountains.

Wild Roses

Use a photograph as inspiration for an attractive flower painting

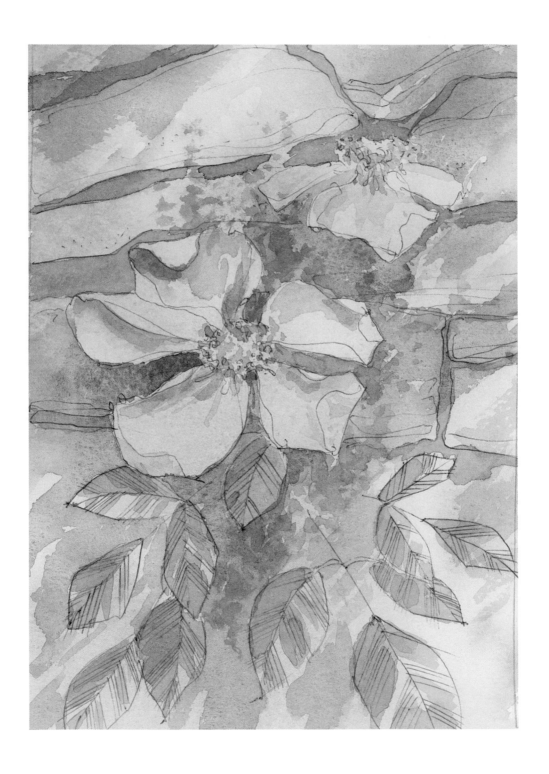

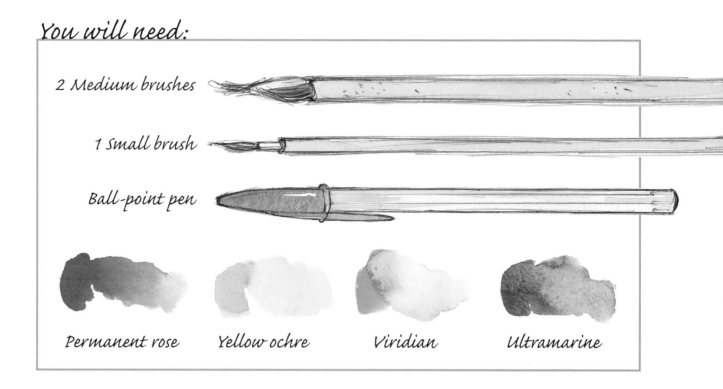

You will need:

2 Medium brushes

1 Small brush

Ball-point pen

Permanent rose Yellow ochre Viridian Ultramarine

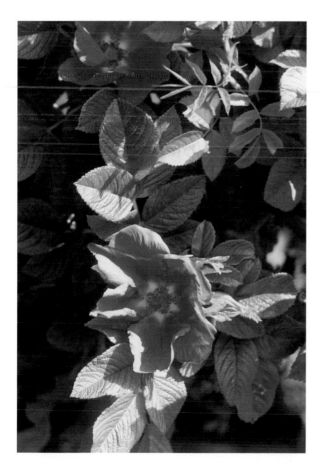

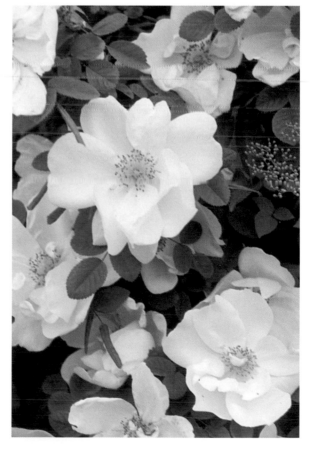

These photographs of wild roses will offer inspiration

TINTING THE PAPER

With a medium brush, prepare watery puddles of yellow ochre, permanent rose and viridian. Use the other medium brush to wet the paper then gather the excess water to a corner and dab with a paper towel. While the paper is still wet, apply yellow ochre all over with permanent rose mostly at the top and viridian mostly at the bottom. Dry the paper.

2 PRACTISE THE FLOWERS

Practise sketching the flowers with a ball-point pen before drawing them onto your tinted paper. Start at the centre of the paper using dots to form the shape. Draw an uneven number of petals.

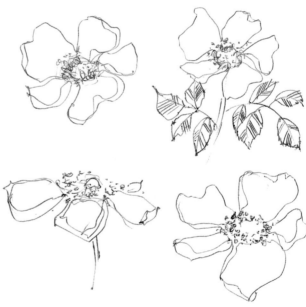

Practise sketching the flowers before drawing them onto your tinted background

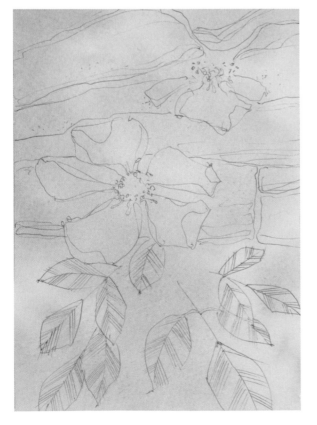

3 SKETCHING ONTO THE BACKGROUND

Using the ball-point pen sketch the first flower slightly off-centre. Position the second flower higher but keeping it close. Fill the bottom area with stems and leaves. Draw in some dry stone wall shapes.

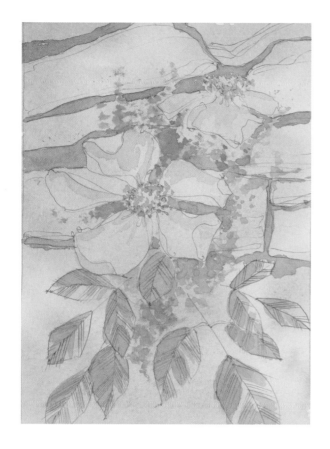

4 FURTHER DETAILS

Using a small brush paint yellow ochre centres.
Mix viridian and yellow ochre to get a mid-green
and use this to paint the leaves and background
foliage. Use a wash of permanent rose to add some
definition to the petals. Mix some viridian with
permanent rose and use this dark bluey-green to
paint the stone wall crevices and to over-paint some
of the leaf shapes. Mix a small watery puddle of
viridian and paint this over some of the leaves.
Dry the paper.

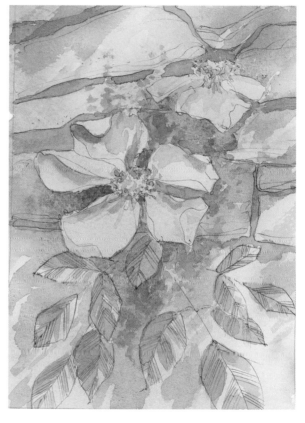

5 CREATING SHADOWS

Make a weak puddle of ultramarine and using
a small brush paint diagonal shadows on the wall,
leaving some areas unpainted. Paint small areas of
shadow on the petals and the leaves as shown
above. Dry the paper.

Cottage near Rydal Water

Make sketches on-site or from a photograph as
guidelines for a painting

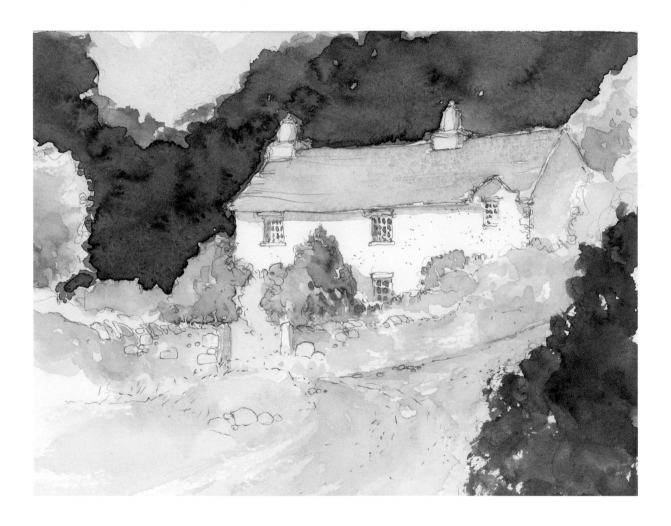

You will need:

Cerulean blue

2 Medium brushes

1 Small brush

Permanent rose

Ball-point pen

Cadmium yellow Viridian Ultramarine

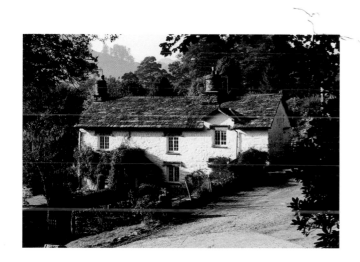

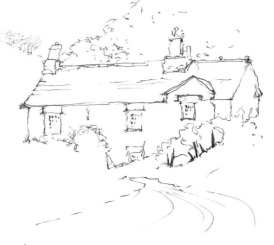

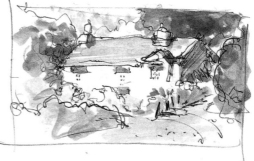

It is a good idea to do a series of sketches before selecting one that you would like to develop further

1 **SKETCHING THE IMAGE**
Use a ball-point pen to draw your initial sketch, so that these lines can then be incorporated into the final painting. Texture the cottage rendering with dots.

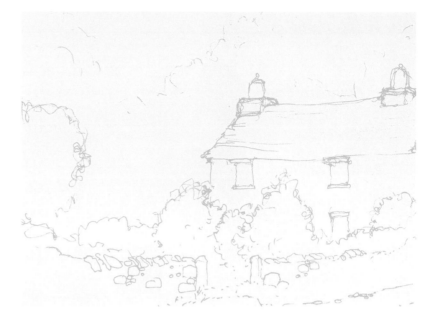

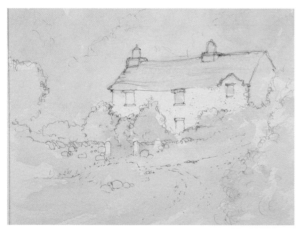

2 **UNDERPAINTING**
Use pale washes of colour as a base to gradually build stronger colours up from. As shown left, use permanent rose on the road, cadmium yellow on areas of greenery, the roof of the house and the wall, and cerulean blue in the background trees and sky.

3 **ADDING DETAIL**
Mix a mid-green to add another layer of colour to the trees and orange to the wall and some of the road. Add a slightly stronger layer of cerulean blue to the distant trees and in the foliage and a stronger permanent rose to the road. Using the cerulean blue experiment with layered colour on the roof. Dry the paper.

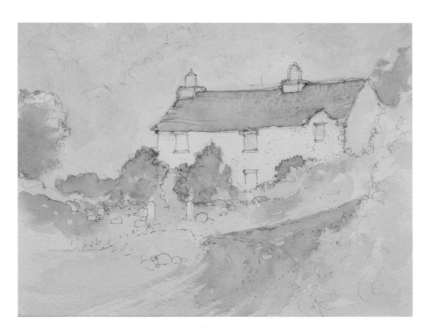

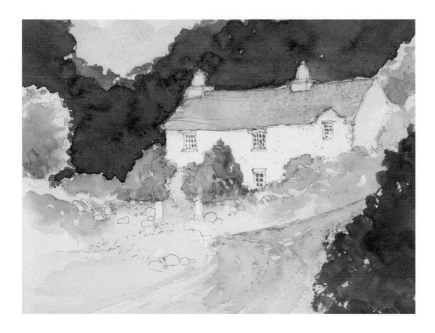

4 ADDING DARKER AREAS

Mix permanent rose and viridian to make a very powerful dark colour. Load a medium brush with this colour and apply the mix with circular motions behind the cottage, on some of the trees in front of the cottage and on the trees in the bottom right-hand corner of the painting. Use this same colour to dot in the window panes. Dry the paper.

5 SHADOWS

Using the small brush and a weak ultramarine wash, paint in the shadows of the windows, the chimneys, the gable end, the eaves, the wall and its shadow on the road. Add some extra yellow and green to the front wall. Dry the paper.

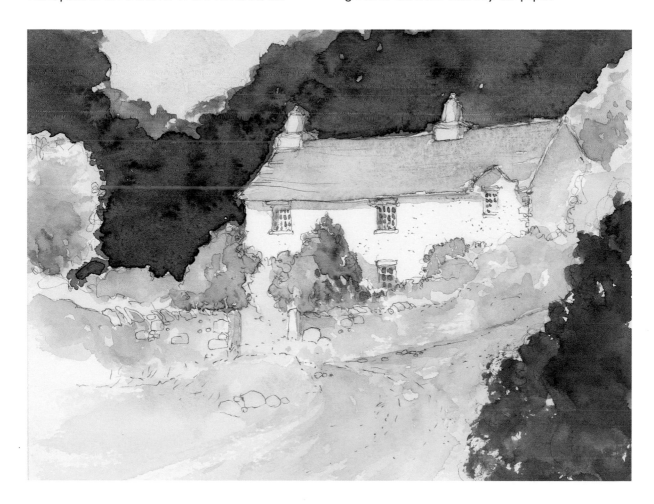

Misty Morning

This atmospheric composition can be achieved in just three stages by
painting atmospheric shapes onto a colour-wash background

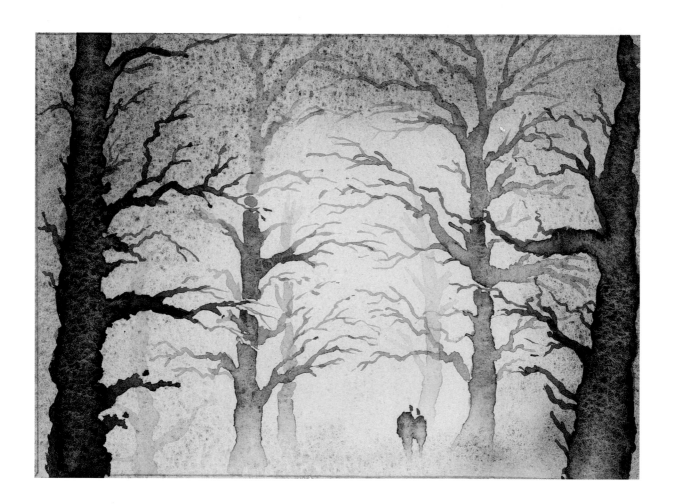

You will need:

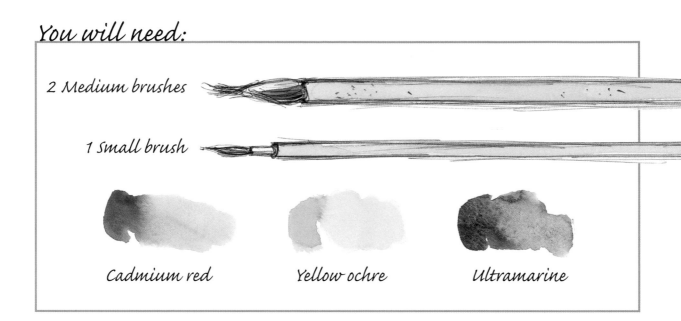

2 Medium brushes

1 Small brush

Cadmium red Yellow ochre Ultramarine

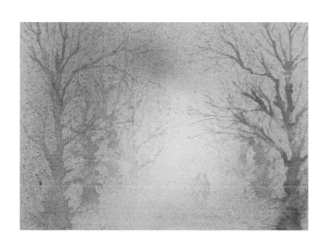

Experiment with using different colours to change the mood of the picture. This painting uses ultramarine as the predominant colour for a cooler feel

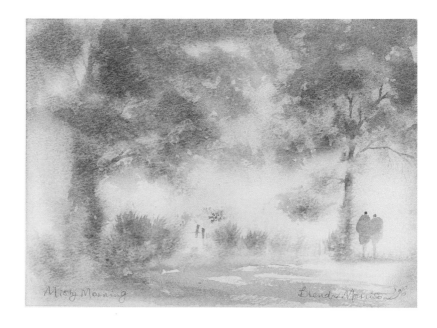

1 TINT THE PAPER

Wet the paper and apply a watery yellow ochre slightly off-centre and a watery cadmium red around that. Mix a large portion of a watery ultramarine and cadmium red and use this to paint the remaining outer area of the background. Dry the paper.

2 POSITIONING THE TREES

Mix a large puddle of ultramarine with a small of amount of cadmium red and practise painting the trees. Make a wetted shape for the lower trunk then paint the tree shapes upward out of the wet area and into a dry area. Once you are confident with painting the trees, paint them onto your tinted background. Working from the outer edge of the paper paint the two trees on the left-hand side first then the two on the right. Add a small amount of water to this mix to lighten it slightly then paint the two pale trees in the centre. Dry the paper.

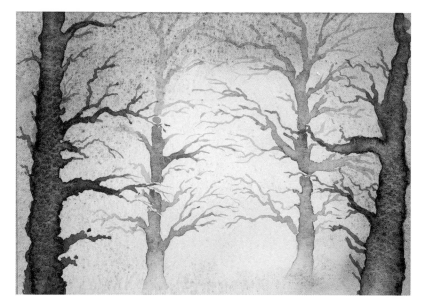

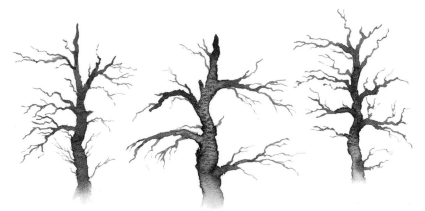

Practise painting the trees before adding them to your final composition. Make them slightly lighter as you work inwards

Paint the figures so that they fade away towards the bottom

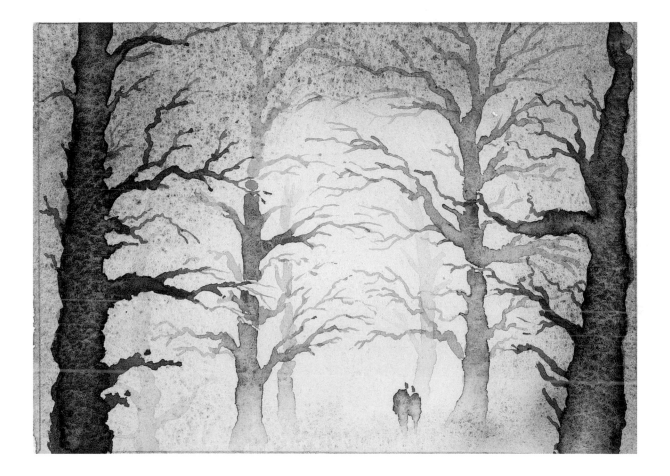

3 POSITIONING THE PEOPLE

Using the same mix of ultramarine and cadmium red as for the trees, take a small brush and copy the shapes of the people above, starting at the shoulders and moving downwards to the feet. Dab the lower half of each figure with a paper towel to lighten it. Alternatively, repeat the above process to halfway then pick up a small amount of water to continue the shape downwards. This will lighten the colour. When you are satisfied with your figures add them onto your paper close to the bottom and slightly to the right of the centre of the picture. Dry the paper.

Index

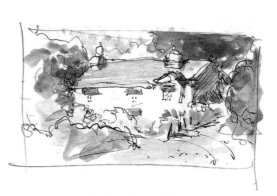

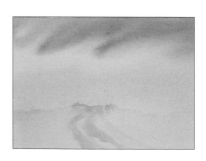

GMC Publications

CRAFTS

Bargello: A Fresh Approach to Florentine Embroidery
 Brenda Day

Beginning Picture Marquetry Lawrence Threadgold

Blackwork: A New Approach Brenda Day

Celtic Cross Stitch Designs Carol Phillipson

Celtic Knotwork Designs Sheila Sturrock

Celtic Knotwork Handbook Sheila Sturrock

Celtic Spirals and Other Designs Sheila Sturrock

Celtic Spirals Handbook Sheila Sturrock

Complete Pyrography Stephen Poole

Creating Made-to-Measure Knitwear: A Revolutionary
 Approach to Knitwear Design Sylvia Wynn

Creative Backstitch Helen Hall

Creative Log-Cabin Patchwork Pauline Brown

Creative Machine Knitting GMC Publications

The Creative Quilter: Techniques and Projects
 Pauline Brown

Cross-Stitch Designs from China Carol Phillipson

Cross-Stitch Floral Designs Joanne Sanderson

Decoration on Fabric: A Sourcebook of Ideas Pauline Brown

Decorative Beaded Purses Enid Taylor

Designing and Making Cards Glennis Gilruth

Designs for Pyrography and Other Crafts Norma Gregory

Dried Flowers: A Complete Guide Lindy Bird

Exotic Textiles in Needlepoint Stella Knight

Glass Engraving Pattern Book John Everett

Glass Painting Emma Sedman

Handcrafted Rugs Sandra Hardy

Hobby Ceramics: Techniques and Projects for Beginners
 Patricia A. Waller

How to Arrange Flowers: A Japanese Approach to English
 Design Taeko Marvelly

How to Make First-Class Cards Debbie Brown

An Introduction to Crewel Embroidery Mave Glenny

Machine-Knitted Babywear Christine Eames

Making Decorative Screens Amanda Howes

Making Fabergé-Style Eggs Denise Hopper

Making Fairies and Fantastical Creatures Julie Sharp

Making Hand-Sewn Boxes: Techniques and Projects
 Jackie Woolsey

Making Mini Cards, Gift Tags & Invitations Glennis Gilruth

Native American Bead Weaving Lynne Garner

New Ideas for Crochet: Stylish Projects for the Home
 Darsha Capaldi

Papercraft Projects for Special Occasions Sine Chesterman

Papermaking and Bookbinding: Coastal Inspirations
 Joanne Kaar

Patchwork for Beginners Pauline Brown

Pyrography Designs Norma Gregory

Rose Windows for Quilters Angela Besley

Silk Painting for Beginners Jill Clay

Sponge Painting Ann Rooney

Stained Glass: Techniques and Projects Mary Shanahan

Step-by-Step Pyrography Projects for the Solid Point
 Machine Norma Gregory

Stitched Cards and Gift Tags Carol Phillipson

Tassel Making for Beginners Enid Taylor

Tatting Collage Lindsay Rogers

Tatting Patterns Lyn Morton

Temari: A Traditional Japanese Embroidery Technique
 Margaret Ludlow

Three-Dimensional Découpage: Innovative Projects for
 Beginners Hilda Stokes

Trompe l'Oeil: Techniques and Projects Jan Lee Johnson

Tudor Treasures to Embroider Pamela Warner

Wax Art Hazel Marsh

DOLLS' HOUSES AND MINIATURES

1/12 Scale Character Figures for the Dolls' House
 James Carrington

Americana in 1/12 Scale: 50 Authentic Projects
 Joanne Ogreenc & Mary Lou Santovec

A Beginners' Guide to the Dolls' House Hobby Jean Nisbett

Celtic, Medieval and Tudor Wall Hangings in 1/12 Scale
 Needlepoint Sandra Whitehead

Edwardian-Style Hand-Knitted Fashion for 1/12 Scale Dolls
 Yvonne Wakefield

How to Make Your Dolls' House Special: Fresh Ideas for
 Decorating Beryl Armstrong

Making Miniature Chinese Rugs and Carpets
 Carol Phillipson

Making Period Dolls' House Accessories Andrea Barham

Miniature Bobbin Lace Roz Snowden

Miniature Crochet: Projects in 1/12 Scale Roz Walters

Miniature Embroidery for the Georgian Dolls' House
 Pamela Warner

Miniature Embroidery for the Tudor and Stuart Dolls' House
 Pamela Warner

Miniature Embroidery for the 20th-Century Dolls' House
 Pamela Warner

Miniature Embroidery for the Victorian Dolls' House
 Pamela Warner

Miniature Needlepoint Carpets Janet Granger

More Miniature Oriental Rugs & Carpets
 Meik & Ian McNaughton

Needlepoint 1/12 Scale: Design Collections for the Dolls' House Felicity Price

New Ideas for Miniature Bobbin Lace Roz Snowden

Patchwork Quilts for the Dolls' House: 20 Projects in 1/12 Scale Sarah Williams

Simple Country Furniture Projects in 1/12 Scale Alison J. White

GARDENING

Alpine Gardening Chris & Valerie Wheeler

Auriculas for Everyone: How to Grow and Show Perfect Plants Mary Robinson

Beginners' Guide to Herb Gardening Yvonne Cuthbertson

Beginners' Guide to Water Gardening Graham Clarke

Big Leaves for Exotic Effect Stephen Griffith

The Birdwatcher's Garden Hazel & Pamela Johnson

Companions to Clematis: Growing Clematis with Other Plants Marigold Badcock

Creating Contrast with Dark Plants Freya Martin

Creating Small Habitats for Wildlife in your Garden Josie Briggs

Exotics are Easy GMC Publications

Gardening with Hebes Chris & Valerie Wheeler

Gardening with Shrubs Eric Sawford

Gardening with Wild Plants Julian Slatcher

Growing Cacti and Other Succulents in the Conservatory and Indoors Shirley-Anne Bell

Growing Cacti and Other Succulents in the Garden Shirley-Anne Bell

Growing Successful Orchids in the Greenhouse and Conservatory Mark Isaac-Williams

Hardy Palms and Palm-Like Plants Martyn Graham

Hardy Perennials: A Beginner's Guide Eric Sawford

Hedges: Creating Screens and Edges Averil Bedrich

How to Attract Butterflies to your Garden John & Maureen Tampion

Marginal Plants Bernard Sleeman

Orchids are Easy: A Beginner's Guide to their Care and Cultivation Tom Gilland

Plant Alert: A Garden Guide for Parents Catherine Collins

Planting Plans for Your Garden Jenny Shukman

Sink and Container Gardening Using Dwarf Hardy Plants Chris & Valerie Wheeler

The Successful Conservatory and Growing Exotic Plants Joan Phelan

Success with Cuttings Chris & Valerie Wheeler

Success with Seeds Chris & Valerie Wheeler

Tropical Garden Style with Hardy Plants Alan Hemsley

Water Garden Projects: From Groundwork to Planting Roger Sweetinburgh

PHOTOGRAPHY

Close-Up on Insects Robert Thompson

Digital Enhancement for Landscape Photographers Arjan Hoogendam & Herb Parkin

Double Vision Chris Weston & Nigel Hicks

An Essential Guide to Bird Photography Steve Young

Field Guide to Bird Photography Steve Young

Field Guide to Landscape Photography Peter Watson

How to Photograph Pets Nick Ridley

In my Mind's Eye: Seeing in Black and White Charlie Waite

Life in the Wild: A Photographer's Year Andy Rouse

Light in the Landscape: A Photographer's Year Peter Watson

Outdoor Photography Portfolio GMC Publications

Photographers on Location with Charlie Waite Charlie Waite

Photographing Fungi in the Field George McCarthy

Photography for the Naturalist Mark Lucock

Photojournalism: An Essential Guide David Herrod

Professional Landscape and Environmental Photography: From 35mm to Large Format Mark Lucock

Rangefinder Roger Hicks & Frances Schultz

Underwater Photography Paul Kay

Viewpoints from Outdoor Photography GMC Publications

Where and How to Photograph Wildlife Peter Evans

Wildlife Photography Workshop Steve & Ann Toon

The above represents a selection of the titles currently published or scheduled to be published.
All are available direct from the Publishers or through bookshops, newsagents and specialist retailers.
To place an order, or to obtain a complete catalogue, contact:

GMC Publications, Castle Place, 166 High Street,
Lewes, East Sussex, BN7 1XU, United Kingdom
Tel: 01273 488005 Fax: 01273 402866

www.gmcbooks.com E-mail: pubs@thegmcgroup.com

Orders by credit card are accepted

BEGINNING
Watercolours

BEE MORRISON

GUILD OF MASTER CRAFTSMAN PUBLICATIONS

Dedicated to all my friends who knew that this book was possible. Especially to my husband Geoff for all his loyal support over the years.

First published 2004 by
Guild of Master Craftsman Publications Ltd
166 High Street, Lewes
East Sussex, BN7 1XU

Text and images © Bee Morrison 2004

© in the work Guild of Master Craftsman Publications Ltd

ISBN 1 86108 339 4

British Cataloguing in Publication Data

A catalogue record of this book is available from the British Library.

Publisher: Paul Richardson
Art Director: Ian Smith
Managing Editor: Gerrie Purcell
Production Manager: Stuart Poole
Photographer: Anthony Bailey
Editor: Clare Miller
Art Editor: Gilda Pacitti

Colour reproduction by Icon Reproduction, UK
Printed and bound by Stamford Press, Singapore